UNDERGROUND
Bases and Tunnels

••

What is the government trying to hide?

by RICHARD SAUDER, Ph.D.

Adventures Unlimited Press
One Adventure Place
Kempton, Illinois 60946 USA

Underground Bases and Tunnels:
What Is the Government Trying To Hide?

ISBN 0-932813-37

Published by
Adventures Unlimited Press
One Adventure Place
Kempton, Illinois 60946 USA
Telephone 815-253-6390
Fax 815-253-6300

Jacket and book design by Dependable Type

Printed in the United States of America

Table of Contents

THE NEW SCIENCE SERIES:
•MAN-MADE UFOS: 1944—1994, 50 Years of Suppression
•THE FREE ENERGY DEVICE HANDBOOK
•THE FANTASTIC INVENTIONS OF NIKOLA TESLA
•THE ANTI-GRAVITY HANDBOOK
•ANTI-GRAVITY & THE WORLD GRID
•ANTI-GRAVITY & THE UNIFIED FIELD
•VIMANA AIRCRAFT OF ANCIENT INDIA & ATLANTIS

THE LOST CITIES SERIES:
•LOST CITIES OF ATLANTIS, ANCIENT EUROPE & THE MEDITERRANEAN
•LOST CITIES OF NORTH & CENTRAL AMERICA
•LOST CITIES & ANCIENT MYSTERIES OF SOUTH AMERICA
•LOST CITIES OF ANCIENT LEMURIA & THE PACIFIC
•LOST CITIES & ANCIENT MYSTERIES OF AFRICA & ARABIA
•LOST CITIES OF CHINA, CENTRAL ASIA & INDIA

THE MYSTIC TRAVELLER SERIES:
•IN SECRET TIBET by Theodore Illion (1937)
•DARKNESS OVER TIBET by Theodore Illion (1938)
•IN SECRET MONGOLIA by Henning Haslund (1934)
•MEN AND GODS IN MONGOLIA by Henning Haslund (1935)
•DANGER MY ALLY by Michell-Hedges

Foreword
A CAUTIONARY NOTE TO UFO BUFFS

Persistent rumors of secret underground bases and deep underground tunnel systems have swirled through the field of UFOlogy for some years now.

These underground installations are variously said to be constructed, staffed and operated by covert human agencies (either part of the military-industrial complex or various federal government agencies), or by extraterrestrial or alien beings (the so-called "Little Greys" often mentioned in the UFO literature), or by both covert human agencies *and* aliens working together in secret, underground installations.

I will say at the outset that my research has not revealed whether or not Little Greys even *exist*, much less whether or not they are living and working in underground installations. Perhaps the Little Greys really do exist; perhaps they do not. But since I cannot definitively answer the question one way or the other, I will not deal with it to any great degree in this report. Neither will I discuss reported cases where abductees have been taken into purported underground installations, where they have allegedly seen and experienced many strange things, including bizarre medical procedures and biological engineering experiments. Though I have both heard and read such stories I cannot testify as to the veracity of these reports, so I will not concentrate on them here. These anecdotal accounts are interesting, however, and I am

keeping an open mind about them.

What I do know for certain is that there *are* many underground installations here in the United States.

I also know that the military-industrial complex and various federal government agencies have constructed, and are working in, many of these installations.

I also know that throughout virtually the entire post-WW II period (and perhaps before) the United States government has been actively planning and constructing underground facilities and installations, some of which are very deep underground, quite sophisticated and capable of accomodating large numbers of people. I have documented quite a number of these facilities and will describe them, to the extent that I am able, in this book. I have also been told of many other underground facilities that I am presently not able to document. For that reason, most of them will not be discussed here.

I have been able to find *considerably less* information about the much-rumored tunnel system said, by some reports, to crisscross the United States. This does not mean that it does not exist. It may simply be that its deep underground location (if it really exists) gives it a natural cover that is hard to break. Or maybe it really does not exist! I don't know for sure one way or the other. Whatever the case, I will present what information I have uncovered about tunneling technology and tunnel systems -- the kind of information that may well form the popular basis for the rumored underground tunnel system.

My approach to the tunneling and tunnel network issue is the same as to the underground base question: I will present for my readers reports, information and facts that I have discovered and leave them to draw their own conclusions. I trust that most of what follows will be as

new and intriguing for others to read as it was for me to discover.

I understand that some readers may object to the publication of information about military facilities. However, it is my feeling that the aims and ideals of representative democracy are poorly served by secrecy in government, especially in the policies of the armed services.

History teaches us that when a country has an exceptionally powerful military, and when that military carries out secret policies and agendas like the U.S. military does (think of the illegal Iran-Contra affair, of super-secret nuclear bomb testing in Nevada, of the astronomical amounts of money given to the Pentagon every year for so-called "black projects"), then there is an ever present danger of that military taking control of the government. That control could be taken quickly -- or gradually. Noisily or quietly. But dictatorships are born when power is usurped by the military. God forbid that a military dictatorship should ever march under the stars and stripes of the United States of America. Protection against that ever happening begins with the exercise of our First Amendment right to speak freely.

So, in that spirit, and in the hope that some of what follows will help peel away the cover of excessive secrecy that shields too much of what the Pentagon does from public scrutiny, I offer solid documentation of underground military installations, as well as official plans and documents pertaining to the construction, operation and planning for such installations.

I would like to briefly relate an unpleasant incident involving the U.S. Army Corps of Engineers. In December 1992, while researching this book, I filed a Freedom of Information Act Request with the U.S. Army Corps of

Engineers. My request sought information about the Corps' involvement in underground base and tunnel construction and maintenance. As it happens, I was at that time a PhD candidate in political science working on my doctoral dissertation. After getting no substantive response to my request, I called the Pentagon and was referred to the Army Corps' Freedom of Information Office. I subsequently called that office and complained about the Corps' noncompliance with my request. A few days later an attorney for the Army Corps of Engineers called my dissertation advisor to complain about me. He informed my dissertation advisor that if I wanted to get bureaucratic that he would show me what "bureaucratic" *was*!

Subsequently I received a letter from the Corps denying my request for a fee waiver and stating that I would have to pay all fees related to searching for and providing documentation on their subterranean construction and maintenance activities. Needless to say, this could easily have run to thousands of dollars.

As a result, that information is not in this report. However, I still found plenty of other information relating to the U.S. Army Corps' underground construction activities and it is all discussed in detail in the pages that follow. So the Army's attempt at suppressing my First Amendment rights was not entirely successful. The free press lives!

Chapters 7 and 9 of this book were first published in *UFO Magazine*, edited by Vicki Cooper.

Readers are welcome to forward information to me concerning underground installations or tunnels of any sort. The more specific and detailed the information is, the better. Clear photographs, with accompanying details about when and exactly where they were taken, as well as what they depict, are also welcome. Sending photographs

or information to me constitutes permission for future publication or use by me, at my discretion, without further obligation or compensation to the sender. Please request anonymity if you want it. My address is:

Richard Sauder
c/o Adventures Unlimited
Box 74
Kempton, IL 60946 USA

Now, let's go underground -- and see what's there!

RICHARD SAUDER, Ph.D.
January 1995

Chapter One
OH YES, THEY'RE REAL!

Do secret, underground government installations
exist? The answer is absolutely, positively -- yes. *They are
real.*

In 1987, Lloyd A. Duscha, the Deputy Director of
Engineering and Construction for the U.S. Army Corps of
Engineers, gave a speech entitled "Underground Facilities
for Defense -- Experience and Lessons." In the first
paragraph of his talk he referred to the underground
construction theme of the conference at which he was
speaking and then stated: "I must deviate a little because
several of the most interesting facilities that have been
designed and constructed by the Corps are classified." Mr.
Duscha subsequently launched into a discussion of the
Corps' involvement, back in the 1960s, in the construction
of the large NORAD underground base beneath Cheyenne
Mountain, Colorado (See Chapter 3 for a more detailed
discussion of the NORAD installation). And then he said:
*"As stated earlier, there are other projects of similar scope,
which I cannot identify, but which included multiple
chambers up to 50 feet wide and 100 feet high using the same
excavation procedures mentioned for the NORAD facility."*[1]

I submit that you will probably not find a more honest
admission anywhere by a military officer that the Pentagon
has, in fact, constructed secret underground installations.

Given such an explicit admission, within the context of the paper trail that the military has left over the last 35 years (set out in this book in considerable detail), and the stories that I have heard from other individuals, I consider it an absolute certainty that the military has constructed secret underground facilities in the United States, above and beyond the approximately one dozen "known" underground facilities listed elsewhere in this book.

Just a few of the many places where these underground facilities are alleged to be are: Ft. Belvoir, Virginia (home of the Army Corps of Engineers); West Point, New York (site of the Army's officer training academy); Twentynine Palms Marine Corps Base, in southern California; Groom Lake or Area S-4, on or near Nellis Air Force Base, in southern Nevada; White Sands Army Missile Range, New Mexico; under Table Mountain, just north of Boulder, Colorado; under Mount Blackmore in southwestern Montana and near Pipestone Pass, just south of Butte, Montana. I would be glad to hear from individuals with information about any of these alleged facilities.

But not all underground installations are secret military projects. Many underground tunnels and facilities have been built that are not covert in any way. There are numerous highway and railroad tunnels, and many major cities have extensive subway systems. There are also miles of utilities, such as water lines and sewer tunnels, with accompanying pumping stations.

Some of the most complex, non-covert underground facilities that have been built are for hydroelectric powerhouses. The rooms and halls in these kinds of plants can be hundreds of feet below the surface and quite huge in some cases. For example, the powerhouse at Portage Mountain Dam in British Columbia, Canada is 890 ft. long,

66.5 ft. wide and 152.5 ft. from top to bottom. Of special note is the method used to deliver concrete to the powerhouse chamber during construction. An 8-in diameter pipe was run 400 ft. from the ground surface down to the construction area, and the concrete was delivered through the pipe.[2]

But if such extraordinary human ingenuity and effort can bring into being the tunnels through which we freely drive our cars, and the power stations which deliver electrical power to our homes, it requires no great stretch of imagination to suppose that installations of similar, or even greater, size, complexity and depth could have been built underground, perhaps covertly, by agencies of the United States government and huge corporations. As this book reveals, our government -- and the contractors with which it works -- has the personnel, technical know-how, machinery and money to plan and complete mammoth underground construction projects.

Where are the bases?

In the pages that follow I will list, one by one, as many of the known underground facilities in the United States and Canada that are operated or maintained by United States government agencies and major corporations as I can presently document, reporting as much information about each one as possible. For some, I can report only that they exist; for others, I can say a good deal more. As it happens, there are many similar deep underground facilities in other countries. Sweden, Switzerland, France, Saudi Arabia, Israel and Russia are known to have sophisticated underground installations -- and, presumably, yet other countries have them as well. In this book I will restrict my discussion only to North American facilities.

So there is no question that secret underground bases

exist. *But how do they get there?* How is it possible to plan, build, and operate them, all in secrecy? As it happens, it is easier than the average person might suspect.

In 1985 the U.S. Army Corps of Engineers published a report entitled *Literature Survey of Underground Construction Methods for Application to Hardened Facilities.* The report concluded that, "Since adequate technology is available to construct hardened underground facilities under virtually any ground conditions, the main constraint in construction projects remains economic viability rather than technical feasibility." In other words, with enough money, underground facilities can be built almost anywhere. Given the huge buildup in military budgets under the administrations of Ronald Reagan and George Bush one cannot help but think that "economic viability" -- money -- may not have been a drawback at all, especially for projects done beginning in the early 1980s.

In very general terms the Army Corps report discusses a variety of types of underground facilities and construction techniques. Two of the types of underground facilities it discusses are (1) deep shaft structures and (2) tunneled structures in mountainsides.

Inspect Illustration 1.[3] Notice that tractor trailer trucks are depicted as entering both kinds of structures. In the mountainside facility the truck appears to drive in through a tunnel. In the deep shaft structure truck entry appears to be via an access building and some kind of vertical hoist or elevator that would seem to be implicit in the layout of the facility. The deep shaft structure is also shown with an accompanying ventilation shaft to the surface, which has its topside terminus in a "protective enclosure."

How To Hide An Underground Base

To illustrate just how well hidden such underground

facilities -- and the entrances that give access to them -- can be, consider the examples of two actual, underground installations. One of them is in England, the other in Sweden. First, the Swedish installation:

> In central Sweden there is an underground factory excavated deep into a granite mountain which employs nearly 3,000 workers and manufactures diesel and gasoline engines, agricultural machinery, and various machine tools. As you approach this installation, the only man-made structure apparent to the unaccustomed eye is an innocent looking Swedish farm house, located at the foot of a hill. However, when the hinged walls of this house swing open, much like large garage doors, there is an opening of sufficient size to accomodate large trucks.[4]

Consider that these words were written in 1949, during the immediate post-war period. If in the 1940s the Swedes could disguise the entrance to a major, underground, industrial facility as an ordinary farm house, what might the Pentagon be capable of today? Clearly, the possibilities are extensive.

Now for the English example. Until 1989 the War Headquarters of the British Army's UK Land Forces Command was situated in an underground bunker 50 ft. below a field in Sopley, Hampshire. When it was active the sign in front of the installation identified the place as a "training area" for the "No. 2 Signals Brigade." (This is more than a little reminiscent of the two U.S. Army "Warrenton Training Center" stations mentioned later.) The English bunker has now been replaced by a newer facility elsewhere, but the interesting thing about the now abandoned Sopley facilities is how nondescript the entrance is.

> On the surface, only a guardhouse and two ventilator shafts
> now stand in an empty, but fenced-off field ... A shaft
> concealed at the back of the innocuous looking guardhouse
> gives access to a stairwell and underground tunnel -- at the
> end of which is a two-story bunker with about 50 rooms.[5]

I strongly suspect that the designers here in the United
States have been at least as ingenious as their counterparts
in Europe in disguising and concealing entrances to
underground installations. Virtually any house anywhere,
or any building, large or small, is capable of concealing an
entrance to an underground facility. This is not the same,
of course, as saying that every house and building that one
sees *is*, in reality, a disguised underground base entrance.
Still, as the above examples show, *some* houses and
buildings certainly *can be* disguised entrances for such
facilities. Since they don't have signs on them advertising
the fact, the hard part is figuring out *which* ones they are.
To say that this is not easy is an understatement.

Starting Construction: One Case History

So underground bases do exist and they can be
hidden. But how do underground construction projects get
underway in the first place, without being noticed?

Consider Kennesaw Mountain, just outside of Marietta,
Georgia, in the late 1950s, and Green Mountain, on the
outskirts of Huntsville, Alabama.

Two articles in 1957 reported that the Army was
planning to build a huge underground rocket factory inside
Green Mountain. The project was to have been undertaken
jointly by the American Machine and Foundry Company,
the Redstone Arsenal and the Army Ballistic Missile
Agency. In addition to the missile plant, the facility was

also slated to have a "sort of subterranean 'junior Pentagon' where elaborate headquarters would be install-ed to direct the defense of the southern U.S. from enemy attack." A local group bought 200 acres along the Tennessee River for docks from which a company called Chemstone would ship the limestone excavated during construction to market.[6] This same group, comprised of members of the Huntsville Industrial Expansion Committee, also engaged in a nearly two-year "series of obscure real estate transactions" in which they purchased, "in their own names or through proxies, various parcels of land scattered about ... Green Mountain"[7] for the construction of the underground, military-industrial facility.

I don't know if this base was ever actually built (if you do, please contact me). But whether or not it actually moved to the construction phase is beside the point here. It is fascinating enough to see how a site is selected, bought and prepared for construction.

The preparation and preliminary work proceeded in a most interesting fashion, in that, even though it was to be a combination underground "junior Pentagon" and U.S. Army missile factory, the land for it was actually purchased not by the Department of Defense, but by private citizens, acting on their own or as proxies for others. The plan for the facility is also intriguing in that, as of 1957, it clearly showed the kind of military-private industry cooperation that has today become commonplace. In this case, it involved the U.S. Army and the American Machine & Foundry Co.

So already in 1957 the Pentagon -- and local business interests -- showed themselves capable of coming together to plan the construction of a major underground military facility, to be built inside of Green Mountain, in the

southern Appalachians, just outside of Huntsville, Aalabama. That nexus of interests was comprised of (a) big business; (b) military agencies; and (c) private individuals who were in on the deal (and who very likely benefitted from insider speculation in the local real estate market). Underground base researchers would do well to look for this nexus of interests and pattern of activity elsewhere, as similar groups are likely to have played key roles in planning and constructing underground facilities in other places.

Here is the way I see the actual construction scenario playing out: military agencies desire to construct underground facilities as secretly as possible. The Army Corps of Engineers can supervise the actual construction and draw up the plans, but special expertise and equipment will often need to be supplied by private industry. And specific or highly technical industrial operations will likely need to be conducted by private companies as well. Although the Pentagon and other federal agencies (notably the U.S. Forest Service, National Park Service, Bureau of Indian Affairs, and the Bureau of Land Management) control huge tracts of land in the West, in other parts of the country most of the land is owned by private citizens. So if a military agency wishes to secretly construct a base on a piece of land that it does not own, in order to avoid drawing attention to its plans, it might covertly employ a sympathetic group of private citizens or businessmen to handle the real estate transaction(s) for it. In this way, the military gets its land, but without unwanted publicity and fanfare.

The *Air Force Times* announced in 1959 that the Air Force was on the verge of agreeing with the U.S. Department of the Interior to place an underground SAGE radar facility inside of Kennesaw Mountain (the mountain

was, and is, a National Park owned by the Interior Department), on the outskirts of Marietta, Georgia. Construction was projected to last two years and to cost about $15 million (in 1959 dollars). The facility was to be a "semi-automatic Air Defense Center" for the surrounding 13 state region.[8] I do not know if this installation was ever built. The mountain is only a few miles from Dobbins Air Force Base, so it would have been possible to drive a tunnel the short distance from Dobbins AFB and excavate the inside of the mountain without disturbing the surface of the national park in the slightest. All of the heavy machinery required to build the facility could have entered and exited the underground construction site via Dobbins AFB.

Whether this was in fact done I do not know. But even if neither the Kennesaw Mountain nor the previously mentioned Green Mountain underground facilities were ever constructed the mere fact that plans to do so were announced demonstrates that the Pentagon, as of the late 1950s, was actively planning for underground bases in the southern Appalachian region. Not only that, but the plans were in an advanced stage of preparation. (Turn to Illustration 2 to see how military planners in the late 1950's were visualizing their underground bases.)

So even if these two particular facilities were not built (and I do not know one way or the other) my research leads me to believe it is likely that others were built in northern Alabama and Georgia, and in the Carolinas, and perhaps in Tennessee as well.

Of course, major underground projects would probably get underway in much the same way in any other state or region of the country.

Supplying Power to Underground Military Facilities

A primary consideration in the construction of deep-underground facilities is obtaining sufficient power for operation once the installation is built and functioning. By the early 1960s the U.S. military had decided that "... either of two prime power plant systems would provide suitable sources of electrical power for hardened, underground Command Centers. These two are the diesel power plant and the nuclear power plant."[9] While it may seem possible to plug into the commercial network that services most of the country for the electrical power needs of underground facilities, a 1963 Army report concluded that the power requirements of these installations can be sufficiently unique, due to "stringent voltage and frequency requirements which may be imposed by special electronic equipment," and due to the necessity of power self-sufficiency under emergency conditions, "that it is far more satisfactory, and in many cases more economical, to provide a generating plant within the installation itself to serve all the load and to eliminate any connection to a commercial power source."

The 1963 Army report concluded that "...nuclear power plants appear to be advantageous for use in underground installations." And it effectively endorsed their use in underground military installations: "...(N)uclear power is the only field tested, non-air-breathing system with sufficient electrical generating capacity to support an underground installation of the size and type envisioned." The report then proceeded to discuss the pros and cons of various power plants, most of them conventional, before concluding with a list of the various nuclear power plants already built, under construction or being designed for military use.[10] However, the report

unfortunately did not specify for what size and type underground installation these power plants were intended, or where the facilities may be located. But the very existence of an Army Corps of Engineers manual entitled *Utilization of Nuclear Power Plants in Underground Installations* means it is entirely possible that underground military facilities may be powered by self-contained nuclear power plants.

In the case of diesel power plants, during emergency "button-up" periods when the installation would be sealed from the outside world, there would be a so-called "closed-cycle" system in operation. This system would utilize sodium hydroxide for disposal of carbon dioxide in the exhaust produced by the diesel engines; liquid oxygen stored in cryogenic tanks for combustion of the diesel fuel; and fuel oil to power the diesel engines, stored in an underground depot, and replenished as needed from tanks on the surface.[11]

Other proposals that have been advanced to generate independent power economically are detailed in Chapter 5.

The secret underground bases exist; they can be well hidden; and they can be independently powered.

In the next chapter I take the reader on a guided tour of underground bases throughout the United States. No doubt the locations of some of these bases will be a surprise to many!

Chapter Two

THE MILITARY UNDERGROUND: AIR FORCE, ARMY AND NAVY

It is important, first of all, to realize that the United States military has been heavily involved in underground construction for decades. I will set out for you as many of the locations where the various military agencies have actually constructed major underground facilities as I can presently document. I have been told of, and have read of, many others. While I think it highly probable that at least some of these other secret installations may exist I will not discuss most of them in this report, because I cannot presently document them.

I will also discuss at some length planning documents generated by various military agencies pertaining to construction and operation of underground bases and tunnel systems. These planning documents are real. They were written over a 25 year period beginning in the late 1950s and continuing up to the mid-1980s. The reader will have to be the judge of whether any of the underground facilities discussed in the planning reports have been constructed. I personally have not been in any underground military facilities and am not privy to classified information; however my hunch is that some of the facilities mentioned in these reports and studies probably *were* built.

The Air Force and Project RAND

One of the most prominent names in the early history of U.S. government planning for underground bases is Project RAND. The RAND Corporation became operational in November 1948. It actually grew out of U.S. Air Force Project RAND, which was established in 1946 to carry out long-range research projects of interest to the Air Force. The mission of the RAND Corporation was to work on cutting edge problems in the realms of engineering, economics, mathematics, physics and social science.

In the late 1950s, one of the problems that the RAND Corporation was working on was the question of underground base construction for the United States military. Accordingly, Air Force Project RAND and The RAND Corporation held a symposium on this topic, on 24-26 March 1959, to which they invited a wide variety of technical experts from the public and the private sector. According to the chairman, the purpose of the symposium was to discuss "the problems of protecting military installations located deep underground or under mountains" in the event of nuclear war.

He went on to say that for the two years previous (since 1957) The RAND Corporation had been "actively investigating the need for a small number of superhard deep underground centers" that could withstand the fury of a massive nuclear attack.[1] The two-volume report itself is made up of dozens of papers about tunneling, underground excavation, geology, engineering technology and the like. Most of the papers are quite general.

The major importance of this RAND Corporation sysposium, however, is that it reveals that already in the 1950s the U.S. government was actively planning for the construction of underground bases and installations. (In fact, as I shall show later, already in the 1950s the United

States government had constructed a number of secret, deep underground installations.)

Also noteworthy is the way in which the groundwork for the move underground was prepared: The RAND Corporation called on experts from military and nonmilitary government agencies, from the corporate world and from major universities. Chairmen for the individual sessions were drawn from Princeton University; RAND Corporation; Colorado School of Mines; Army Corps of Engineers; University of Illinois; National Bureau of Standards; Ballistic Research Laboratories; Brown University; and an assortment of independent consultants and private firms. This pattern of collaboration on underground construction projects between university researchers and university engineering schools, private sector industry and the military and other government agencies is one that has continued right up through the 1980s.

In 1960 the RAND Corporation published a study under contract to the Air Force in which twelve specific locations across the country were selected as *possible* sites for deep underground installations. In this RAND Corporation report, all installations are assumed to be more than 1,000 ft. underground.[2]

One of these sites, on the Keweenaw Peninsula near Calumet, Michigan, was selected for its location under places where previous hard rock mining had occurred. The theory expressed in the report was that in the event of a nuclear attack, seismic waves from the detonation of nuclear weapons on the surface would be attenuated and deflected by the previously excavated shafts, tunnels, drifts, rooms and chambers of the copper mine workings, thereby shielding the underground installation from the full brunt of a nuclear explosion. In the cases where such

mine workings did not already exist, so-called "umbrellas" could be excavated above the installation. These are open spaces in the rock that would serve the same purpose of protection as mine workings.[3]

Another site where a facility was proposed was under an abandoned iron mine near Cornwall, Pennsylvania.[4] Other sites proposed for deep underground military installations were Mohave and Coconino Counties, Arizona, under the Grand Wash and Vermilion Cliffs; a limestone mine near Barberton, Ohio, about 8 miles from Akron; The Book Cliffs near Rifle, Colorado, where the federal government already has excavated an oil shale experimental mine; the area near Morgantown, West Virgina; the area of McConnelsville, Ohio, between the towns of Marietta and Zanesville; the northwest corner of Logan County, Illinois, about 25 miles south of Peoria; an indeterminate location in southwestern Minnesota; the thick diatomite strata of Santa Barbara County, California; and lastly, and perhaps most interestingly, under the glacial ice and rock of the Kenai Peninsula in southern Alaska. In the last two cases, it was felt that the chalk-like diatomite and the glacial ice would help absorb the considerable force of a nuclear blast and thereby afford a greater measure of protection to the deeply buried facility.[5]

While I do not know if the Air Force has constructed underground installations at the 12 locations specified in the RAND report, there is no question that the Air Force *does* have underground installations that *can* be documented. One such facility, little known, is in operation near Albuquerque, New Mexico. The site is referred to as the Kirtland Munitions Storage Complex by the Air Force, which for years would not comment on what was there, though speculation was rampant that the complex was a nuclear weapons storage area.

In 1949 the Air Force dug into one of the ridges in the foothills of the Manzano mountains near Albuquerque and began to fill it with tunnels and caverns.

One of the miners who helped excavate the complex personally told me of blasting out large chambers underground, 40 ft. wide, 30 ft. high, and 100 ft. long. Security during construction was so tight that as soon as his crew completed a tunnel or chamber they were pulled out and sent away to excavate another portion of the mountain. This was compartmentalization of the most literal kind, intended to ensure that not even the miners who built this underground base would be familiar with its complete layout.

The miner further told me that this facility contains a covert, subterranean, nuclear weapons assembly plant. Another man I have spoken with who has been inside the facility told me that it seemed to him that the mountain contained miles of tunnels. This second man also said that there was a secret nuclear weapons assembly plant inside the mountain (See Illustration 3).

Security at the facility, which is clearly visible a couple of miles to the south of I-40 on the eastern outskirts of Albuquerque, is *extremely* tight. The 3,000 acre base, actually a separate base within the Kirtland AFB/Sandia National Laboratories complex, is ringed by a 9.5 mile concentric band of four, tall, chain-link security fences, the third of which carries a lethal electrical charge, and the fourth of which is topped by coils of razor-sharp concertina wire.[6] Entrance to the facility is via secure blast doors set into the mountain. Until recent years, armed police in jeeps patrolled the perimeter around the clock.

In 1989 the Air Force began construction of a second underground facility within sight of the Manzano Base. The new facility, completed in June of 1992, is also on land

controlled by Kirtland Air Force Base. 95% of the new, 285,000 sq ft. bunker is below ground.

I was told by one of the Marine guards at the new facility that in addition to more prosaic security measures such as magnetically coded ID cards there are also devices that scan the palm print and retina of the eyes of each person seeking entry. But he would tell me no more about the facility than that.

According to the Air Force, whatever used to be in the Manzano complex has now been transferred to the new underground bunker. However, this sheds little light on what was transferred to the new bunker since Air Force officials have never in the first place discussed what used to be in the Manzano complex. And although the Air Force may have announced that it has vacated the mountain, it is hardly empty. A recent report indicates that the Department of Energy (DOE) now occupies 50% of the Manzano bunker complex. But like the Air Force before it, the DOE is not commenting either about what it is doing in the Manzano base. Nuclear arms experts speculate that nuclear weapons are being stored in both the new bunker and the old Manzano base.[7] And they may well be right.

On the other hand, even supposing that nuclear weapons are in either or both of these underground bunkers, it is still entirely possible that something more than weapons storage is happening below the surface at Kirtland. Indeed, if my two sources are correct there was in the past, and still may be, a secret nuclear weapons assembly plant underground, beneath the foothills at Kirtland Air Force Base.

Knowing from published newspaper accounts in the local *Albuquerque Journal* that the Department of Energy (DOE) had moved into 50% of the large underground facility on Kirtland Air Force Base, I filed a Freedom of Information Act (FOIA) request with the DOE's Wash-

ington, DC office. I asked for information about the underground facility at Kirtland. I also asked for information about other underground facilities rumored to be operated by the DOE at Los Alamos, New Mexico; the huge Pantex nuclear weapons factory near Amarillo, Texas; the Rocky Flats nuclear facility in Colorado; and an unusual electronics facility called "ICE STATION OTTO," located in a very rural area a few miles north of Moriarty, New Mexico on Highway 41.

My request was sent to the DOE's Albuquerque office at Sandia/Kirtland. (Sandia National Laboratories, run for decades for the Department of Energy by AT&T, are now administered by Martin Marietta. Sandia Labs are located on Kirtland Air Force Base.) In their initial response to me, DOE denied that they have any records of underground facilities at any of these sites. Or, in DOE jargon, "no responsive records to your request were located."

Well, that's an interesting response, because the local newspaper has reported actual underground facilities at Kirtland AFB that are fully 50% occupied by the DOE. Once again, a government agency has refused under the Freedom of Information Act even to release information that is readily available in the public domain.

I have been told that there *are* underground facilities and tunnels at Los Alamos National Labs as well. But the DOE response to my request said that there were *none*. When I received this response I called up the appropriate DOE personnel and informed them that the FOIA office at Los Alamos was not forthcoming. In reaction to my phone call the DOE again queried the Los Alamos FOIA office. Within a couple of days the DOE at Los Alamos provided a badly blurred photostatic copy of an article by Earl Zimmerman entitled "LASL'S Unusual Underground Lab," which describes an underground laboratory built in the late

1940s (See Illustration 4 for a photograph taken from inside this mysterious facility).[8] But the DOE included no information as to when, or in what magazine or journal the article appeared. At my request the Sandia office again called the Los Alamos DOE office for more information and was told they did not know the facts of publication of the article and that they had no other information about this underground facility.

Hmm.

Isn't it interesting that Los Alamos' first search found no records responsive to my request, but the second search did? As best as I can make out from the barely legible text in the photostat of the article about the LASL, the facility was constructed in 1948-49 by the huge fabrication company of Brown & Root, Inc., of Houston, Texas. The main tunnel was designed by a company called Black and Veatch, of Kansas City, Missouri. It was bored into the cliffside of Los Alamos Canyon, at a place called TA-11 or perhaps TA-41 (owing to the poor quality of the xerox the numbers are indistinct). Opening off of the main tunnel, which was quite large and could accomodate a large truck for nearly 250 feet of its length was a thick vault door, behind which was a high security room, containing five more, thick, vault doors containing multiple combination locks, of the sort that banks have for their vaults. Behind each of these doors was a walk-in vault. The whole complex was "lined with reinforced concrete, equipped with three sources of electric light and power, modern plumbing, forced ventilation and air conditioning." The climate control called for a "constant humidity of about 50 percent and a temperature that remained between 40° and 60°." A spur tunnel led to another room that contained an emergency diesel generator, to supply power in the event that outside sources were cut off. In an emergency

batteries could also provide lighting. The complex was located beneath the Noncommisssioned Officers Club.

The complex was reportedly originally built to store nuclear materials, and later converted to a fall-out shelter, designated as Shelter 41-004 (here again the numbers are indistinct). In an emergency it contained supplies to take care of 219 people for two weeks. According to the article, construction details of the 6,000 sq ft. underground facility were declassified in 1959.

Interestingly, the article says that its vaults are "still used as vaults and security is just as strict as ever." And the article alludes to the facility's use as a "pure physics" laboratory. The article also mentions that the complex was associated with something called "W Division."

In subsequent communications with the DOE I received information indicating that this facility was in active use as recently as the mid-1980s.

The existence of this facility raises many questions. The most logical is: are there other tunnels and other high security suites of vaults and rooms deep under Los Alamos? And in light of persistent rumors of captive "EBEs"[9] held hostage at Los Alamos, was this high security, climate controlled, plumbing equipped suite of vaults *really* dug into the mesa as a storage site for nuclear materials -- or was that just a cover story? Was this complex, instead, actually intended as a high security jail for alien prisoners held against their will, incommunicado behind thick steel doors, deep underground? Certainly the time frame of 1948-1949 is suggestive, since that is the approximate time when one, possibly more, UFOs were rumored to have crashed and to have been retrieved, along with some of their occupants, by the U.S. military.

But perhaps the only secrets being protected here

really did revolve around the infant nuclear industry. After all, in the late 1940s the nuclear age was still in its infancy and Los Alamos was the place where the atom bomb was developed and first produced. So it would have made perfect sense to have a local, high security, underground facility for storing nuclear materials.

Something Old, Something New

Yet another provocative underground Air Force installation has recently been reported in the heart of California's wine country.

Within the last couple of years a secret underground installation has allegedly been covertly constructed near Oakville Grade, not far from Napa, California. Aerial photographs of the entrance to the supposed underground facility, located in rugged, mountainous terrain, show "large cement bunkers with large concrete doors, a new road, freshly graded." There are also eight to ten microwave dishes pointing straight up into the sky, evidently providing satellite communications links. There has been heavy helicopter traffic to the facility, evidently to outfit and provision it. When asked about the flights the Air Force responded that they were a "classified operation." According to a local newspaper the new facility is an "elaborate underground complex designed to hold government officials, scientists and other high echelon personnel in the event of an emergency."[10]

U.S. Army Corps of Engineers

A big player in the underground installation business is the U.S. Army Corps of Engineers -- and the "regular" Army itself.

Given the RAND Corporation symposium in 1959, it is no surprise that in the years 1959-1961 the U.S. Army

Corps of Engineers published a five-part series of training manuals entitled *Design of Underground Installations in Rock*. I cannot possibly condense the entire contents of these documents here, nor will I cite them all. But suffice it to say that the tone of the series assumes that there already were underground military installations, as of the late 1950s. The manuals are clearly intended for use by military engineers training for the construction and maintenance of underground facilities. Judging from the manuals, the facilities in question were intended for use as command and control centers and survival bunkers for the military brass, in the event of nuclear warfare.

Citing the failure of the Germans and Japanese to recognize early enough in WW-II the strategic importance of placing crucial facilities underground, the Army Corps concluded that it was imperative for the United States to construct vital facilities deep underground. This decison was lent extra force by the destructive power of nuclear weapons which made previous installations obsolete. Significantly, one of the reports in this series, issued in 1961, says, *"Vital governmental installations have been placed underground, as exemplified by the Ritchie project."*[11]

The Ritchie project is a large, underground, military facility on the Maryland-Pennsylvania border which is discussed in some detail later in this report. The interesting thing here is that already in 1961, in a publicly available document, explicit reference is made to governmental installations (plural) *already* having been placed underground.

Examples of the sorts of facilities the military was discussing placing underground were: communications centers, fortifications, air raid shelters, staff headquarters and offices, research facilities, shops and factories, and storage areas; and hospitals, kitchens, lavatories and

sleeping areas for the use of the personnel stationed underground. According to the Army Corps, some facilities were to be relatively shallow, while other, "more important equipment and facilities essential to defense may be installed in deeper workings" that "are likely to be long and tunnel-like," occupying "one or several stories." According to the report, such deeper facilities may be several hundred feet underground. Several kinds of facilities are discussed: (a) a simple installation with a single shaft or tunnel; (b) a simple installation with two or more shafts; (c) a simple installation with tunnel and shaft; and (d) larger installations with multiple tunnels and shafts for access and ventilation.[12]

The documents provide several possible schematic layouts for underground installations (See Illustration 5 for one such schematic). In addition to the tunnels giving access to the facilities there are also shafts to the surface for ventilation, heating and cooling, and for exhaust of gases from power plant machinery. The documents also show possible designs and appearances of air-intake shafts for underground facilities (Illustration 6) and how an exhaust system for an underground power plant might look (Illustration 7). According to the report, sewage would be piped out of the facility and treated at a nearby plant. There would also be spray ponds, cooling towers, or other air conditioning equipment visible on the surface in the near vicinity of an underground installation, besides air-intake shafts or vents, and exhaust pipes for the power plant. Water would be supplied both from outside commercial sources and also from wells sunk near or from *within* the facility. Large reservoirs would be hollowed out underground to provide operational water reserves for emergencies. The facilities discussed in the report would also contain kitchens, snack bars, cold storage areas,

dispensaries or first aid rooms, medical facilities, personnel lounges, barracks, auditoriums and conference rooms.[13]

Readers should keep in mind that these facilities could be almost anywhere and could be quite large. According to the report, they could be constructed inside "hills or plateaus" with *concealed shaft entrances* (my italics). There need not necessarily be any conspicuous hoist house for a vertical shaft since the "principal parts of a hoist plant may ... be contained underground." Tunnels could be as large as 50 ft. by 50 ft. in diameter and chambers as much as 100 ft. high. In some installations "truck or rail traffic might be important." In such cases provision would have to be made for "narrow-gauge rail transportation" or "single-lane highway tunnels," or perhaps even for "two-track railroad or two-lane highway tunnels" as much as "31 ft. wide by 22 ft. high." And it is possible that quite large entrances to underground facilities could open directly off of major canals, lakes, rivers, bays and even the open sea, since the report says that "...an installation might require entrances for barges or ships." The manual goes on to say that, "Landscape scars, roads, and portal structures (entrances) should be as inconspicuous as possible. Camouflage should be considered." Actual underground layout of the chambers in the installation might be in a parallel configuration with connecting shafts and tunnels as necessary or desired for utilities, ventilation, passageways, etc.; or there might be either "radial chambers connected at center, ends, and at regular intervals to form a spider-web pattern," or "chambers in concentric circles or tangents with radial connections," after the manner of the Pentagon.[14]

Certainly, this series of official Army documents, which explicitly discusses constructing large underground installations, some set inside of hills and plateaus with concealed shafts and portals, and underground hoisting

plants and water wells, perhaps with entrances for barges and ships, and maybe even with tunnels that can accomodate two lanes of truck traffic or two-track railways, ought to give considerable pause to reflect. At the very minimum, they mean that at least as early as the late 1950s the Army was training its engineers to design such facilities. In fact, it seems very likely that the Army has built underground facilities similar to the ones described in the five-report series. It also seems very possible that they may be camouflaged or concealed, and for that reason, hard to detect.

In a three-volume report issued in June and July of 1964 and entitled *Feasibility of Constructing Large Underground Cavities,* the Army Corps of Engineers sets out 12 sites across the country (See Illustration 8) where it calculated 600 ft. diameter cavities could be excavated, up to 4,000 ft. underground. The ostensible reason for constructing these huge underground caverns was to have been for conducting underground nuclear tests. The idea was to "decouple" the blast by situating the explosion in a huge, deeply buried cavity. In that way, seismic energy produced by a nuclear explosion could be muffled, rendering detection (presumably by the Russians) problematic. Let me emphasize that I do not know whether any of these twelve, huge, very deeply buried cavities were ever excavated. And if they were excavated, I do not know if they were used for nuclear testing or for something else.

If actual nuclear tests were carried out in large cavities, deep underground, which had the effect of greatly attenuating the explosion, making detection by the Russians difficult, then it is possible that detection was difficult for others as well. Conceivably, these others could have been local American citizens who may have merely heard what they thought was a muffled sonic boom, or felt

what they perceived as an unexplained, perhaps unquestioned, short-lived rumbling underfoot. But that is speculation. Maybe the cavities were never excavated. Or perhaps they *were* excavated, but used for another purpose unrelated to nuclear testing.

In any event, *Volume I* begins by observing that if the surrounding rock is structurally sound "... construction of a spheroidal cavity at least 200 ft. and possibly as much as 600 ft. in diameter and located 3000 to 4000 ft. below the ground surface presents no unsolvable construction problems." It further concludes that, "... a number of sites are available within the continental United States in which large cavities up to the maximum size considered in this report can be constructed." The authors state that a 200 ft. cavity would require two years and $8.5 million dollars to construct. The relevant time and money for a 600 ft. cavity were calculated at 3½ years and $26.7 million. And all at 3000 to 4000 ft. underground. At the time this report was issued, all of the sites in the western part of the country were on federally owned land, some of them on or near military reservations. Most of the sites were also in regions of low population density.[15]

Interestingly, the first report estimates that construction of a 600 ft. diameter cavity would create about 4.2 million cubic yards of rock, not including the muck (excavated rock and soil) from the construction of the access tunnel.[16] The third report in the series estimates that construction of a 600 ft. diameter cavity and access tunnels would create about 7.0 million cubic yards of muck which could be disposed of in an *80 acre dump area* (my italics).[17] Both reports allude to concealing, camouflaging or blending the muck dumps into the terrain, so that construction of the tunnel and cavity would be harder to detect.

Volume I goes into lengthy geological discussions of the various sites. Interested readers should consult the document directly for more detail than can be provided here. I will simply list the 12 sites, giving directions to the planned locations of the underground facilities that are as precise as possible.

SITE 1- YUMA COUNTY, ARIZONA. Access via vertical or inclined shaft. The site is located either in the Gila, Copper or Cabeza Prieta Mountains, or conceivably in all three ranges. Yuma, Arizona lies 40 miles northwest of the central Gila Mts. Ajo is about 25 miles east of the boundary of the general area in question. U.S. Highway 80 and the Southern Pacific Railroad cross the northern part of the area. When the report was issued parts of the area were controlled, respectively, by the Yuma U.S. Marine Corps Air Station, the U.S. Air Force Gila Auxiliary Air Force Base and a wildlife refuge.

SITE 2- MOHAVE COUNTY, ARIZONA. Access via vertical shaft. The location is in the east-central Hualapai Mountains (Gila and Salt River Base Line and Meridian). The site is reached by a secondary road that heads south along the base of the range from Arizona Highway 93. Kingman is about 30 miles northwest.

SITE 3- INYO COUNTY, CALIFORNIA. Access via inclined shaft. The five potential sites are located in the Argus Mountains and near the town of Darwin. The report says the two most important locations, from the standpoint of geological conditions that are favorable for constructing a large, underground cavity, are sites D and E. Site D is 4 miles due west of Darwin; Site E is several miles northwest of Trona, directly under Argus Peak. This is a few miles inside the boundary of the China Lake Naval Weapons Center.

SITE 4- MESA AND MONTROSE COUNTIES, COLORADO. Access via vertical shaft. The areas lie in the Sinbad and Paradox Valleys; two sites, one approximately 30 miles east, and the other about 40 miles southeast, of Moab, Utah. The site in Paradox Valley can be reached from Nucla, Colorado by State Route 90; the one in Sinbad Valley can be reached by State Route 141, out of Grand Junction, Colorado, and an unimproved road along Salt Creek Canyon.

SITE 5- PERSHING COUNTY, NEVADA. Access via vertical or inclined shaft. The site is located in a U.S. Naval Gunnery Range in the Shawave and Nightingale Mountain Ranges. To reach the area take unimproved roads from State Highway 34. Lovelock, Nevada is 30 miles to the east and Fernley, Nevada is south 35 miles.

SITE 6- MESA COUNTY, COLORADO. Access via vertical, inclined or horizontal shafts or tunnels. The location is in Unaweep Canyon, approximately 30 miles southwest of Grand Junction, Colorado. State Highway 141 runs through the area. (See Illustration 9)

SITE 7- EMERY COUNTY, UTAH. Access by vertical shaft. The area is called Horse Bench and is 10 miles south of U.S. 50, and just to the southeast of State Highway 24. Green River, Utah, is about 10 miles to the northeast.

SITE 8- WINKLER AND NORTHERN WARD COUNTIES, TEXAS. Access by vertical shaft. Located near the small towns of Kermit and Wink, Texas. 50 miles west of Odessa, access is by U.S. Highway 80.

SITE 9- MOHAVE COUNTY, ARIZONA. Access by vertical or inclined shaft. Site is on the western edge of the Grand Wash Cliffs, at head of Grapevine Wash. The location is northwest of Kingman, accessible by secondary roads from U.S. Highway 93.

SITE 10- FRANKLIN COUNTY, ALABAMA. Access by vertical shaft. The site is about 10 miles southwest from Russelville, near the small community of Gravel Hill. U.S. Highway 5 is about 5 miles to the east.

SITE 11- KANSAS AND NEBRASKA GRANITIC BASEMENT AREAS. Access by vertical shaft. No specific site was chosen, as the region has many useful sites where the geology is favorable for deep underground construction. Red Willow County, Nebraska was chosen as an example.

SITE 12- OGLETHORPE AND PARTS OF GREENE, WILKES AND ELBERT COUNTIES, GEORGIA. Access by vertical shaft. One proposed site is near the community of Stephens, one mile due east of Highway 77 and the Georgia Railroad. There are a number of other potential sites for deep excavation in these counties in northeastern Georgia in a general area that lies about 20-30 miles from Athens.[18]

Any of these 12 potential sites would be fertile ground for research and investigation, even now. I would like to hear from readers who may have information about underground facilities at these locations.

Volume III of *Feasibility of Constructing Large Underground Cavities* is devoted to an analysis of the cost and constructability of a large cavity 4,000 feet underground, under Argus Peak, or the Southeast Peak, both located several miles to the northwest of Trona, California, within the boundary of the present-day China Lake Naval Weapons Center.

A variety of schemes for access were considered, including vertical and inclined shafts, and long horizontal tunnels, as much as three or four miles in length (See Illustration 10 for the vertical access scheme). The actual facility was planned to be hollowed out from top to bottom, with a spiraling perimeter tunnel and a large

central shaft (Illustration 11). Method of excavation was to be by conventional hard rock mining techniques, using truck mounted mining drills, high explosives, front end loaders, caterpillar tractors, dumptors, etc. Muck (excavated rock) would be removed from underground by either conveyor belts, trolley trucks, mining rail cars, hoists or a combination of rail cars and hoists. Two tunnel sizes for access were considered: (a) 13 ft. in width by 15.5 ft. in height; and (b) 23 ft. wide by 19 ft. high.[19]

I would reemphasize at this juncture that I do not know whether or not any of the cavities discussed in this Army Corps of Engineers document, including the one near Trona, California, were ever excavated. Clearly, a great deal of care and time was invested in this planning study; whether that care and planning translated into actual construction I do not know. I would note, however, that the projected Trona, California site lies just inside the boundary of the China Lake Naval Weapons Center, which has long been rumored to be the site of a massive underground installation. While I cannot speak to the truth of the rumor, I nevertheless find it suggestive that in 1964 the Army Corps of Engineers published a document that sets out in some detail a plan to construct a large, deep underground cavity at that location.

I know from direct experience that at least one U.S. Army facility *does* exist.

The U.S. Army operates a facility in the northern Virginia town of Warrenton. A reported underground bunker known as the U.S. Army Warrenton Training Center, this very secretive installation is supposedly a Federal Relocation Center for an unknown agency.[20] In fact, when I visited the area in the summer of 1992 I decided that there may possibly be two such sites. There are two U.S. Army facilities there, one on Rt. 802 and the

other on Bear Wallow Road, on Viewtree Mountain. One facility is "Station A" and the other is "Station B". Both have signs out front saying "Warrenton Training Center."

When asked about local, underground installations, the person who gave directions to these facilities said that Station B is believed to be a computing and communications facility (this may well be true, judging by the large antennae towering overhead and the AT&T microwave facility located in a field to the rear). He then added, "but no one knows what goes on at Station A." Unfortunately, if the actions of the guard on duty at Station A when I visited are any indication the Army does not want anyone to find out, either.

As I attempted to snap a photo of the gate area from my car the guard sprang into action and bounded toward me waving his arms and angrily shouting, "No!"

Somewhat taken aback at his reaction, which seemed out of all proportion to an innocent snapshot of a government facility, I asked him, "Why not? I'm on a public right-of-way."

He replied even more forcefully, "Because I *said* so!" As he spoke those words, three other security personnel standing just inside the gate began to move toward me. Suddenly feeling very much as if I had abruptly been stripped of citizenship in a democratic republic and had crossed over unaware into some grim netherworld ruled by military decree I gave up trying to take a picture and drove away.

Peering through the fence at the back of the installation I did notice that at Station A there are massively thick power cables that descend utility poles from large electrical transformers and disappear underground.

Navy Plans

If the Air Force and Army are going underground, can the Navy be far behind?

The Naval Facilities Engineering Command issued a report in 1972 that discussed placing several sorts of Navy installations underground.[21] The stated reasons for planning for subsurface naval installations revolved around concerns such as cost efficiency, environmental impact of new construction and the severe land pressures facing many Navy bases, which are hemmed in by surrounding cities and towns. The five sorts of facilities the report's authors recommended for underground construction were:

1) administration buildings
2) medical facilities
3) aircraft maintenance facilities
4) ammunition storage facilities
5) miscellaneous storage facilities

Interestingly, while the report is devoted to a discussion of the merits for the Navy of underground installations, there is also a brief, passing mention made of possible needs for "undersea ports" and emplacements that would service a future, submarine Navy. To be sure, I have heard stories and read rumors of undersea Navy ports at various places along both the Atlantic and Pacific coasts of the United States, as well as in the Great Lakes region. Have they been built? Does this 1972 document hint at what is now a military reality? If you know, please send me the relevant information.

The schematic illustration of the underground weapons storage area is interesting (Illustration 12). Notice that there can be more than one level, and that the complex may extend down several hundreds of feet. Presumably,

the network of shafts and tunnels could also be adapted for other uses besides weapons storage. I consider it entirely possible that these sorts of facilities have been built by the Navy.

But the Navy isn't just interested in underground bomb 'n' submarine parking garages. They're also interested in *your* telephone calls.

The U.S. Navy runs a secret electronics facility near the isolated mountain community of Sugar Grove, West Virginia, on the Virgina-West Virginia line. The purpose of the installation, which works out of a two-story underground operations center, is to spy on microwave communications traffic for the National Security Agency (NSA). This illegal and unconstitutional activity is a serious military violation of civil liberties as set forth in the Bill of Rights.[22]

But if the government doesn't very much care about *your* rights to privacy, it certainly cares a lot about its *own* right to secrecy.

Especially when it comes to fighting war.

In particular, the big one.

Chapter Three

THE ULTIMATE WAR ROOMS: FIGHTING THE BIG ONE FROM DEEP UNDERGROUND

A 1989 article in *U.S. News & World Report* stated that the Federal Emergency Management Agency (FEMA) and the Pentagon administer approximately 50 secret underground command posts around the country, where the president might flee in the event of a nuclear war. (Although FEMA is perceived as a "civilian" federal agency, in reality FEMA and the Pentagon work closely together.) Each of these underground bunkers is "equipped to function as an emergency White House." The article specifically cites the FEMA "Special Facility" at Mount Weather and the Pentagon back-up facility called Raven Rock, or Site R, located along the Pennsylvania-Maryland border, and operated by Fort Ritchie (see the next page for more on the Ritchie facility). Supposedly, in the event of a nuclear crisis, 1,000 civilian and military officials would be rushed to these secret bunkers. They would take refuge there while the rest of the country muddled through the ensuing radioactive holocaust as best it could.[1] In reality, given the number of secret bunkers cited (50), it seems that the number of personnel who would be evacuated would be considerably higher.

The logical question is: where are the underground command posts and bunkers? The answer is not an easy one, since by their very nature these facilities are hard to

find. To begin with, they are all underground. Some of them are on military bases. Virtually all of them have been constructed behind a veil of secrecy and high security. And all of them continue to operate under considerable security.

Nevertheless, at least a partial answer can be provided, because the locations of some of the underground bunkers are known. And information is also available about the function of some of them and what they contain.

THE PENTAGON, NORTHERN VIRGINIA -- As might be suspected, the Department of Defense has burrowed underneath the Pentagon, in Arlington, Virginia and established a sophisticated facility called the "National Military Command Center."

"SITE R", AKA "RAVEN ROCK" OR THE RITCHIE FACILITY -- In the hills of southern Pennsylvania, near the small town of Blue Ridge Summit, is the home of the "Underground Pentagon." Run by nearby Fort Ritchie, since the 1950s the facility has been a major electronic nerve center for the U.S. military. This huge installation, known as "Raven Rock" or "Site R," was blasted out of the native granite known as greenstone and lies 650 ft. below the surface. The 265,000 sq. ft. facility which sprawls beneath 716 acres is comprised of five different buildings in specially excavated separate caverns. It normally is staffed by about 350 people. Access to Raven Rock is by way of portals set into the mountainside. Its corridors are lit by fluorescent lights and it contains a wide variety of amenities including a convenience store; barbershop; medical, dining and fitness facilities; a subterranean reservoir that contains millions of gallons of water; a chapel; 35 miles of telephone lines; and six 1,000 kilowatt generators. "Site R" has long functioned as a sort of second Pentagon and is

equipped as a supercomputing and electronic command post linked with numerous military communications networks all over the globe. Local rumor has it that "Site R" is connected by tunnel to the presidential hideaway at Camp David, several miles away in northern Maryland, near the town of Thurmont. According to a recent press report, with the thawing of the Cold War "Site R" has gone to a standby status and will be staffed at a lower level than in the past.[2]

THE WHITE HOUSE, WASHINGTON, D.C. -- There is a large, sophisticated bunker complex *under* the basement of the White House in Washington, D.C. Dating back at least to the Eisenhower administration, special forces were ready to tunnel down and extract the President from deep underground in the event a nuclear holocaust reduced everything above to rubble.

But just how extensive -- and deep -- is this complex? One source I have personally interviewed claims that there are many, many levels *below* the basement of the White House, that keep going down and down. On one occasion during the Lyndon Johnson administration (in the 1960s), this source was sent to deliver some papers from the Department of Housing and Urban Development (HUD). Upon arrival, my source was escorted by two Secret Service agents to an elevator in an area of the White House that is not open to the public. They entered the elevator and went down for what the source remembers as 17 levels. When the elevator doors opened they stepped out into a corridor covered on the walls, ceiling and floor with beige, ceramic tiles. The corridor was very long, stretching away in the distance to the vanishing point. According to my source, other corridors and doors opened off the main corridor. The fluorescent lighting was recessed in the ceiling. There was a man sitting at a desk by the elevator

doors. The papers were delivered to a man in a room that opened off of the corridor and then my source was escorted back to the elevator, back to the surface and out of the White House. All of the men appeared to be Secret Service agents and were dressed in dark, business suits. The person who related this story to me had the impression there were even more levels below the 17th level. Why papers from HUD had to be delivered to the subterranean bowels of the White House, my source did not know. Whatever the actual size of this underground installation may be, clearly there is far more to the White House than is apparent from driving by on Pennsylvania Avenue.

KANEOHE, HAWAII -- There is also an underground installation at Kaneohe, in Hawaii, connected with U.S. Pacific Fleet operations.

CAMP DAVID, MARYLAND -- At the presidential retreat in northern Maryland, there is "an ultrasensitive underground command post" for the use of the president in an emergency. During the Eisenhower administration this command post was run by a group of military officers known as the "Naval Administrative Unit."[3]

OMAHA, NEBRASKA -- And at Offutt Air Force Base, in Omaha, Nebraska, there is an underground command post for the Strategic Air Command.[4]

Unfortunately, I know little more about these installations than I have set forth here. And that's just the point -- I'm not supposed to know, and neither are you. In the event of nuclear war, we'll be nuclear missile fodder while the President and the Joint Chiefs of Staff huddle underground figuring out how to bounce the rubble one more time. For that type of arrangement to work, you need secrecy, and lots of it.

In a time of nuclear war, or during some other crisis,

when the politicians and military planners go underground, where will they get the information they need to make decisions? Some of the most important information will come from -- you guessed it -- other underground facilities, among them the NORAD facilities described below.

NORAD AT CHEYENNE MOUNTAIN, COLORADO -- For subterranean privacy, try Colorado Springs, Colorado, where the North American Aerospace Defense Command (NORAD) operates perhaps the best known of the major underground bases.

This super-secret facility is located deep inside Cheyenne Mountain, outside of Colorado Springs, Colorado. Here's where the latest space, missile, and air-traffic information is gathered, using state-of-the-art equipment, and fed to military and civilian decision makers.

Planning for the subterranean, 4.5 acre, 15 building complex began in 1956. Construction was started in 1961. The Utah Mining and Engineering Company of San Francisco did the excavating, under the supervision of the Omaha District of the Army Corps of Engineers. The large engineering firm of Parsons, Brinckerhoff, Quade and Douglas was also involved on the project. In 1966 NORAD moved in and began underground operations.

Jointly staffed by United States and Canadian military personnel, the installation constantly monitors all space traffic in and around the earth, all missile launches worldwide, submarine movements and air defenses for North America. This NORAD base is also the National Warning Center for the Federal Emergency Management Agency (FEMA). This is the place from which civil defense warnings for Canada and the U.S. are initiated.[5]

About 1,700 personnel operate the facility around the clock, including a night shift of 300 people. A 4,675 ft.

tunnel bores straight through the mountain. The entrance tunnel is 22.5 ft. high and 29 ft. wide, while the central access tunnel, that branches off the entrance tunnel, is 25 ft. high and 45 ft. wide. Three hundred and fifty hardrock miners, working in three shifts, excavated almost 700,000 tons of granite to construct the facility. The NORAD base is stocked with 30 days of contingency supplies, including enough fuel to run its six diesel generators for 30 days. It also has underground reservoirs, hewn out of solid rock, that hold six million gallons of water for cooling purposes and for use by personnel for domestic purposes. Its 25 ton, hydraulic-operated blast doors, that open off of the access tunnel, well inside the mountain, can open or shut in just 45 seconds. Hardened microwave channels and coaxial cables provide essential communications links for the state-of-the-art electronic and computer systems inside the facility.[6] (See Illustration 50 for schematic diagrams of how these communication links might look.)

NORAD AT NORTH BAY, ONTARIO, CANADA -- This deep underground command center, which is located about 200 miles north of Toronto, is also jointly staffed by both Canadian and U.S. military personnel. The North Bay installation became operational in October 1963 and consists of two huge caverns, bored out of the solid rock, hundreds of feet under the Pre-Cambrian Shield. The two huge caverns, each 400 ft. long, by 60 to 70 ft. high and 45 ft. wide, are connected by three cross tunnels. Inside the caverns, just as at Colorado Springs, three-story buildings have been constructed to house personnel and equipment. There are two access tunnels, the one about 6,600 ft. long and 12 ft. by 12 ft., the other about 3,500 ft. in length and 16 ft. by 16 ft. Inside are 142,000 sq ft. of floor space, filled with offices, communications and computer equipment, and defense radars that cover the northern

sectors of North American air space.

There are also kitchen and dining facilities that can accomodate 400 people, a hospital and infirmary, washrooms and showers, a "well equipped canteen," and space for people to rest and sleep. Power is supplied by six generators that are normally fueled by natural gas piped down from the surface. Under emergency conditions the generators would run off of diesel fuel stored underground in the complex. During normal operations, water for equipment cooling and personnel use is obtained from nearby Trout Lake. But during emergency "button-up" conditions water would come from underground reservoirs specially excavated for use when the facility was sealed off from the outside. One reservoir holds 200,000 gallons for domestic use, and the other contains five million gallons for air conditioning and equipment cooling.[7]

Federal Emergency Management Agency (FEMA)

There are other secret underground government command facilities. Many of them are operated by FEMA, the Federal Emergency Management Agency. FEMA usually pops up in the news as the lead federal agency charged with hurricane or flood relief efforts. But FEMA has another side as well -- a secret, underground side.

MOUNT WEATHER, BLUEMONT, VIRGINIA -- The hub of the FEMA subterranean network is located inside Mount Weather, near the small town of Bluemont, in northern Virginia. This top-secret base was constructed in the 1950s to house the United States government in the event of a national crisis such as nuclear war. Funded by "black" money, Mount Weather remains nearly as inaccessible to scrutiny as it was when first built. Although it is the headquarters for FEMA's far-flung underground empire it

does not even appear in the agency's published budget. Security is tight at the installation, which is surrounded by a 10-ft. perimeter fence patrolled by armed guards. There are a few buildings above ground, but most of the real work of Mt. Weather takes place deep below, in great secrecy. The mountain contains what amounts to a small town. The infrastructure includes: a small lake; a pair of 250,000 gallon water tanks, capable of supplying water for 200 people for over a month; a number of ponds 10 ft. deep and 200 ft. across, blasted out of solid rock; a sewage plant capable of treating 90,000 gallons per day; a hospital; a cafeteria; streets and sidewalks; a diesel powered electrical generating plant; private living quarters and dormitories able to accomodate hundreds of residents; a sophisticated, internal communications system using closed-circuit color TV consoles; a radio and TV studio; massive super-computing facilities; a "situation room" equipped with communications links to the White House and "Site R" in southern Pennsylvania; and a transit system of electric cars that transport personnel around the complex. According to published reports, some of the hundreds of people who work inside the mountain routinely stage practice drills for managing a wide variety of potential crises, ranging from civil disturbances and economic problems, to natural disasters and nuclear war.[8]

Speaking off the record, in the mid-1970s government officials stated that, in fact, Mt. Weather houses a resident, back-up government. Many federal departments and agencies are represented there, including the Departments of Agriculture, Commerce, HUD, Interior, Labor, State, Transportation and the Treasury; and agencies such as FEMA, the Office of the President, the U.S. Postal Service, the Federal Communications Commission, the Federal Reserve, Selective Service, the Federal Power Commission,

the Civil Service Commission and others. These highly placed government sources maintain that the administrators of the Federal departments at Mt. Weather hold cabinet-level rank and are referred to as "Mr. Secretary" by the personnel who work under them. These covert "Secretaries" are said to keep their positions over the course of more than one administration, their terms not being limited by the presidential election cycles that govern the terms of office of their Washington counterparts.[9] These are sensational allegations, but if they are true, then the political news we are fed in the mainstream media must be fictional to some, unknown degree and the system governing us is controlled to that same unknown degree by agencies and officials who work in great secrecy, literally underground and totally unaccountable to the citizenry of the United States.

Mount Weather serves as a hub for a system of other underground installations and bunkers, known as Federal Relocation Centers. These are located within a 300 mile radius of Washington, DC known as the "Federal Arc." Key government officials and personnel would be evacuated to these centers in the event of nuclear war as part of the Continuity of Government (COG) plan. Besides Mt. Weather, there are said to be an additional 96 of these centers in Pennsylvania, Maryland, West Virginia, Virginia and North Carolina.[10]

Presumably, at least some of the approximately 50 secret, underground command posts mentioned earlier in the discussion of military facilities would be among these 96 centers in the FEMA Continuity of Government system. Among other things, the centers are said to contain data files and computer systems maintained by a variety of Federal agencies, and are supervised by the facility at Mount Weather.[11]

A 1991 Jack Anderson column in *The Washington Post* reported that the COG system was created by the Reagan administration and consists of a "$5 billion network of bunkers filled with high-tech communications equipment at secret locations around the country."[12] Just how many of these secret centers were newly constructed during the 1980s, and how many are older facilities that the Reagan adminstration merely converted to its purposes (expanded, remodeled and modernized) is not known. My guess is that at least some of the dozens of secret COG facilities are mentioned in this book. Of course, that would leave dozens of others which are not.

MOUNT PONY, CULPEPER, VIRGINIA -- There are several underground installations either known, or alleged, to exist in the five-state "Federal Arc" area. The best known is probably the large bunker complex that lies under Mount Pony, a couple of miles east of Culpeper, Virginia, just off of Rt. 3 in the northern part of the state. Although one published report identifies this underground facility as the emergency relocation center for the Treasury Department,[13] two other reports,[14] local rumor and the sign by the front gate identify the installation as a "Federal Reserve Center." Constructed in the late 1960s, the 140,000 sq ft. facility is said to be supplied with water, food, a generator, communications equipment and even cold-storage for corpses. One source who formerly worked in the Culpeper area told me it is believed that the Federal Reserve stockpiles very large supplies of United States currency there. Indeed, 5 billion dollars are reportedly stored under Mt. Pony.

But this is not a dormant facility, waiting for Armaggedon before springing to life. From its underground vantage point in Culpeper the Federal Reserve constantly monitors all major financial transactions in the United

States. It does this by means of the "Fed Wire," a modern, electronic system that permits it to keep track of all major business and banking activity that occurs.[15] Why does the Federal Reserve need a secure, underground bunker to monitor the nation's economic life? I don't pretend to know, but clearly, judging by the intermittent traffic going in and out the front gate on the day I visited, the Mount Pony bunker is in active use and doing something.

As it happens, just six weeks after my mid-June 1992 visit to the Federal Reserve's Mount Pony bunker a cover story appeared in *Time Magazine* that dealt, in part, with that very installation. The story said that, as of July 1992 "the facility's mission will no longer be needed."[16] My opinion is that this may well be disinformation. I doubt very much that the Federal Reserve has really abandoned its bunker in Culpeper. And even if the bunker really were to be emptied out, my suspicion is that the contents would merely be transferred to another, more secure location, quite likely also underground.

For what it is worth, I had spoken on the phone with the *Time Magazine* article's author just a few days after visiting the Mount Pony bunker. He wanted to know where I found my information about underground bunkers and installations, and so I mentioned a few of the installations to him that I knew about at that time.

FEMA IN OLNEY, MARYLAND -- Another, less well known, underground installation is located on Riggs Road, off of Rt. 108, between Olney and Laytonsville, MD. Although it has been reported that there are actually two such facilities, a Federal Emergency Management Agency (FEMA) civil defense bunker in Olney and a bunker operated by an unknown government agency in Laytonsville,[17] a recent visit to the area turned up only one site, midway between the two towns. If there is another

bunker in the vicinity it is sufficiently well concealed that it is hard to spot. While it is not clear to passers-by who operates the facility on Riggs Road, since there are only generic United States government "NO TRESPASSING" signs posted on the security fence that surrounds the complex, this site is reportedly the backup command center for FEMA's day-to-day operations.[18] When I arrived the gate was open and no one was in the guard house. However, a prominently placed sign did advise that the entrance area was under electronic surveillance. So presumably, any unauthorized intrusion would not go unchallenged.

The one building visible from outside the fence is in an advanced state of disrepair and gives every appearance of having been vacant for some years. However, the real work at this site takes place beneath the surface. One former Maryland resident who told me of the site spoke of seeing a long line of cars heading through the gate when shifts change and disappearing behind a slight rise in the near distance. I did speak with one man who had been inside the place many years ago on a school field trip. He remembers going down two or three levels and seeing an underground office complex and electronics facilities. This is not surprising given the large number and variety of aerials and antennae visible on the surface. Both this man and another local with whom I spoke said that the bunker is believed to extend as deep as ten levels underground.

THE GREENBRIAR HOTEL, WHITE SULPHUR SPRINGS, WEST VIRGINIA -- Recent revelations about a large, secret bunker beneath the posh Greenbriar Hotel in White Sulphur Springs, West Virginia make clear that it is entirely possible to keep the existence of a large, underground installation out of the public eye for decades on end. Until the story broke in the last week of May 1992 only six members of Congress knew that between 1958 and 1961 a warren of

living quarters, meeting rooms, and banks of computers and communications equipment had been installed underground beneath the hotel, located about 250 miles southwest of Washington, DC in the Allegheny mountains. Situated behind two giant blast doors, each weighing more than 20 tons, and supplied with water, electricity and sewage treatment, the complex is large enough to house eight hundred people. It contains a large dormitory; an infirmary; shower facilities; a television studio; radio and communications equipment; phone booths and code machines; a dining and kitchen area; a power plant; and even a crematorium for getting rid of the corpses of those who might die inside the sealed bunker. According to published reports, the bunker was constructed to shelter the United States Congress in the event of a nuclear attack.[19]

Of course, the obvious question is: in the certain chaos of an impending nuclear war how could the hundreds of members of Congress take shelter in a distant bunker that most of them did not even know existed? According to press reports, only a few local people, the hotel management and maintenance staff, a handful of government officials, and other government personnel with a "need-to-know" appear to have been aware of the installation. Could it be that the bunker has, or had, another purpose which is not being divulged? After all, if the bunker itself was kept secret for over 30 years isn't it conceivable that there is more to the story than has so far been publicly admitted?

FEDERAL REGIONAL CENTERS -- In addition to the huge bunker at Mt. Weather and bunkers in the neighboring states, FEMA also operates underground installations at other sites around the country. Reported locations for these facilities, designated as Federal Regional Centers, are:

Santa Rosa, California; Denver, Colorado; Thomasville, Georgia; Maynard, Massachusetts; Battle Creek, Michigan; Denton, Texas; and Bothell, Washington.[20] There are probably others; these are the ones that can be identified from the public record.

I did file a Freedom of Information Act (FOIA) request with FEMA asking where their underground facilities were located. Even though information about underground FEMA sites is readily available in the public domain, FEMA refused to name them, citing national security provisions of Executive Order 12356, although they did list the following FEMA facilities in a letter to me:[21]

FEMA Headquarters	Washington, DC
FEMA Special Facility	Round Hill, VA
National Emergency Training Center	Emmitsburg, MD
Software Engineering Division	Charlottesville, VA
National Warning Center*	Cheyenne Mountain AFB, Colorado
FEMA Regional Offices (RO)	
Federal Regional Centers (FRC)	
Region I	Boston, MA (RO)
	Maynard, MA (FRC)
Region II	New York, NY (RO)
Region III	Philadelphia, PA (RO)
	Olney, MD (FRC)
Region IV	Atlanta, GA (RO)
	Thomasville, GA (FRC)
Region V	Chicago, IL (RO)
	Battle Creek, MI (FRC)
Region VI	Denton, TX (RO/FRC)

* This is a FEMA presence at a Dept. of Defense facility. Information about that facility would be kept by DOD.

Region VII	Kansas City, MO (RO)
Region VIII	Denver, CO (RO/FRC)
Region IX	Presidio, CA (RO)
Region X	Bothell, WA (RO/FRC)
Communications Antenna Fields	Fort Custer, MI
	Santa Rosa, CA
Strategic Storage Centers (for Disaster Assistance)	
Blue Grass	Richmond, KY
Forest Park	Forest Park, GA
Dempsey	Palo Alto, TX

The observant reader will note that I have already identified 10 of the facilities listed above as underground FEMA installations.

I do not know if any of the other facilities listed in the FEMA response to my request include an underground component. My guess is that some, or all of them, well may. I welcome information from readers who can tell me more.

The Defense Nuclear Agency

In 1975 the Defense Nuclear Agency published a detailed, geological study that discussed dozens of possible sites all over the country for very deeply based military installations -- as much as 5,000 ft. underground.[22] Some of these prospective sites are relatively large in area, while others are fairly limited in geographic extent. Most of them are in the West; a few are located in the mid-West and on the Eastern Seaboard. The report delineated the sites as follows:

East

Adirondack Mountains, New York (in vicinity of Elizabethtown)

3 sites in Central New Hampshire

Area to northwest of Portland, Maine

Northeastern, Central and South Central Virginia

Mid-West

St. François Mountains, Missouri (between St. Louis and New Madrid)

Northern Wisconsin (general area between Chippewa Falls, Wausau and Florence)

Minnesota River Valley (generally 30-40 miles south of Benson and about 50 miles southwest of Minneapolis-St. Paul)

West

Southeastern Wyoming

Rio Grande River Valley, New Mexico (to west and north of Taos; area of special interest 20-30 miles north of Taos, near Colorado border)

Pedernal Hills, New Mexico (60-70 miles east-southeast of Albuquerque)

Zuñi Mountains, New Mexico (100 miles due west of Albuquerque, south of I-40)

La Sal Mountains, Utah (20 miles southeast of Moab)

Sierra Nevada Mountains, California (large area 350 miles long by 50 miles wide)

Idaho Batholith (large area in central Idaho, north of Boise)

South Central Idaho (under Snake River lava flows between Twin Falls and Idaho Falls)

Holbrook, Arizona (general vicinity)

Northwestern Arizona (north of Seligman)

Ash Fork and Williams, Arizona (general vicinity)

Black Mesa Basin, Arizona (under Hopi and Navajo

Reservations)

Book Cliffs-Uncompahgre Uplift. Area along Utah-Colorado border (in general vicinity of and to south of Grand Junction, Colorado)

Monument Uplift and Blanding Basin, Utah (southeastern part of state near towns of Blanding and Mexican Hat)

San Rafael Swell, Utah (west of town of Green River)

Extreme West Central Utah (area 30-40 miles west of towns of Delta and Minersville)

Southwestern Utah (area between towns of Cedar City and Panguitch)

Nuclear Test Site, southern Nevada

Central Nevada (50 mile radius of town of Tonopah)

Northwestern Nevada (50 to 100 miles east and northeast of Carson City)

Special Sites

Washington, D.C. (surrounding area in Virginia and Maryland)

Omaha, Nebraska (general vicinity)

Readers should bear in mind that any installations that may have been built in these areas are likely to be well hidden, and very deeply buried. In addition, since the areas are often rather large, the directions provided are of necessity only a general guide to the location of possible installations. After all, the geological formations of interest to the Pentagon for subterranean bases usually extend for miles. Also, entrances to underground facilities may be some distance away from the base itself. So finding these places is not necessarily an easy task.

My guess is that some of these sites have been used for underground base construction over the last 20 years. Readers who may have information about the presence of

underground bases at any of these sites are urged to get in contact with me.

Deep "Black" Underground: The Oliver North Connection

In Oliver North's autobiography, *Under Fire*, he briefly mentions an extremely secret government program called "The Project." According to North, for a year and a half during Reagan's first term he was the "de facto administrator of The Project" and coordinated a group of expert advisors known as the "Wise Men." The work of the Wise Men and The Project entailed providing for the survival of the United States government in the event of a nuclear war. North specifically says that he wrote policy directives pertaining to The Project which President Reagan signed, and that he also often briefed then Vice-President George Bush about The Project. While North does not say precisely how The Project was carried out he does mention that the Soviet Union had "a network of secret tunnels under Moscow" to which its leaders would flee in time of war, while the United States had nothing comparable.[23] By implication, then, The Project would seem to have provided a similar capability for the United States.

In fact, it seems that The Project did involve an extensive underground construction program. In April 1994 a front page story in the *New York Times* announced the existence of a previously undisclosed program known as "The Doomsday Project." According to the story, the project was an "amalgam of more than 20 "black programs" during the Reagan administration, supervised by George Bush, with some involvement by Oliver North. It reportedly cost some $8 billion to build and took eleven years to complete. The Doomsday Project was concerned with the

survival of the federal government in the event of nuclear war. The project involved many people, including "White House officials, Army generals, CIA officers and private companies." Of direct interest for readers of this book is the fact that the Pentagon built "scores of secret bunkers" as part of something called the "Presidential Survivability Support System."[24] It is my educated guess that many of these "secret bunkers" would be located in the areas and locations set forth in previously discussed documents generated by the Army Corps of Engineers, U.S. Air Force Project RAND and the Defense Nuclear Agency.

Last But Not Least: Underground Command Center For Sale

And finally, this throught-provoking footnote to our tour of underground strategic command centers: As of 1992 there was a decommissioned Strategic Air Command bunker for sale in Amherst, Massachusetts. The 44,000 sq ft. bunker is three stories high, buried under a mountain, blast-proof, climate-controlled, with a glassed-in command theater. It was for sale for just $250,000.[25] There are a couple of interesting things about this piece of information. First, the size and location of this bunker underscore the fact that underground facilities and installations can literally be almost anywhere. Second, the fact that SAC is getting rid of it on the open real estate market means that it must be obsolete. So obsolete that they don't care who goes inside, and they don't care who knows where it is.

One obvious conclusion would be that the Pentagon now has something better, somewhere else.

Chapter Four
MORE UNDERGROUND FACILITIES: MILITARY, GOVERNMENT, NUCLEAR AND BUSINESS

Although I've been told that the Pentagon operates many other underground facilities here in the United States, perhaps dozens more than I've discussed so far, in this chapter, as in the previous chapter, I will err on the conservative side and report only on those underground installations for which I can provide some form of tangible documentation.

Along with military installations I also report on facilities run by other branches of the government, and on some run by private business. Currently, I can positively verify just seven underground corporate facilities. I strongly suspect there are many more. I welcome information in that regard from readers who know of other underground corporate facilities.

But whether it's the Navy or the Federal Reserve or private industry, they all seem to have one thing foremost in their minds: S-E-C-R-E-C-Y.

ATCHISON, KANSAS -- At Atchison, Kansas the Pentagon operates (or used to operate) the Defense Industrial Plant Equipment Facility (DIPEF). This huge underground warehouse facility, with 987,000 total square ft. of space, is a converted and remodeled limestone mine. The facility is serviced by underground roadways that make it easy to

move the thousands of items of machine tools and industrial equipment stockpiled there. Half of the underground area is paved with concrete and the entire facility is climate controlled. As of 1974 138 people were employed at the DIPEF.[1]

THE FEDERAL RESERVE -- A 1981 Wall Street Journal article says that, "Nine of the 12 Federal Reserve Banks have underground emergency quarters, where records are updated daily." I do not know where most of these underground emergency centers are, or how elaborate they are. Neither do I know exactly what kind of records are kept in them. However, since the Federal Reserve is the agency that controls national monetary policy I would speculate that the records it keeps in these underground centers might well have to do with the national money supply and the daily affairs of the world of high finance. Moreover, since we are living in a computerized, electronic era of instantaneous telecommunication I would speculate further that these underground centers might contain sophisticated computing and communications systems. But all this is speculation on my part, since I have never been in the Federal Reserve's underground facilities.[2]

NATIONAL SECURITY AGENCY, FT. MEADE, MARYLAND -- Beneath the National Security Agency's headquarters at Fort Meade, Maryland are "cavernous subterranean expanses," said to be filled with more than ten acres of the most sophisticated supercomputers that money can buy.[3] The NSA operates in tremendous secrecy; however, it is a safe bet based on what is known about the agency that these computers are engaged in a massive surveillance of much of the world's telephone, telegraph, telex, fax, radio, TV and microwave communications, including surveillance of domestic, internal U.S. communications by ordinary citizens. In a word, Big Brother is already here, and his

name is "NSA."

THE DEPARTMENT OF ENERGY'S NEVADA TUNNELS AND
INSTALLATIONS -- The DOE also has many underground
tunnels and installations in Nevada. Most of the DOE
activity appears to be conducted at the Nevada Test Site
(NTS), where the Department of Defense (DOD) and the
DOE have for decades been excavating tunnel complexes
for underground testing of nuclear weapons (See
Illustrations 13 and 14).

These tunnel networks can be quite elaborate (See
Illustration 15). The DOE and DOD sometimes reuse the
tunnels; other times they are apparently abandoned. Their
usual practice is to pack the tunnels with all sorts of
sophisticated, hi-tech equipment and machinery to monitor
the blasts (See Illustrations 16 and 17). Much of the
monitoring takes place within thousandths of a second,
even millionths of a second after the nuclear device
detonates.

I do not know the purpose of all of the hundreds of
underground nuclear blasts (a number that seems
excessively high) detonated by the DOD and the DOE; I
only know that there have been many, many of them and
that there are many tunnels under the nuclear test site. I
do not know where all of the tunnels are, what they are all
used for, or how extensive the interconnections between
them are, providing such interconnections exist at all.

Like many students of UFOlogy I have heard rumors
and read anecdotal accounts that allege there are extensive
underground complexes for living and working under the
Nevada Test Site. I am inclined to think some of these
accounts may be true, but I cannot provide factual
documentation that demonstrates that such facilities exist.

The DOE also operated a test facility at the NTS in the

early 1980s, deep underground, for storing nuclear waste (See Illustration 18).

THE NUCLEAR WASTE DEPOSITORY AT YUCCA MOUNTAIN, NEVADA -- Evidently the nuclear waste storage tests in the early 1980s were successful, or at least encouraging, because in 1991 and 1992 the DOE actively solicited companies for construction of a deep underground tunnel complex inside and beneath Yucca Mountain, about 100 miles northwest of Las Vegas, as another "test" depository for nuclear waste. The actual name of the facility is the "Yucca Mountain Site Characterization Project, Exploratory Studies Facility (ESF)." The solicitations were for companies that can provide: tunnel boring machines (TBMs) capable of boring tunnels of 25 ft. to 30 ft. in diameter; mobile miners and other mining equipment for excavating tunnels; conveyors and muck removal systems; underground ventilation, water and power supply systems; and all requisite support facilities, buildings, roads and equipment for excavating and maintaining a major, underground complex. Construction was slated to begin in November 1992. Reynolds Electrical & Engineering Co., Inc., which is the Prime Management and Operations Contractor for the Nevada Operations Office of the Department of Energy, is the company that will supervise construction and carry out the actual testing at the facility when it is constructed.

The plans call for 14 miles of underground tunnels and ramps, ranging from 14 ft. to 25 ft. in diameter, with grades as steep as -16%. Since the facility also is slated to contain a 1,300 ft. vertical shaft, by implication the complex will be at least 1,300 ft. beneath the surface.

Here again, as with so much of what goes on underground, it is hard to say what the DOE is up to. Maybe they really *are* making a test facility for long-term

storage (10,000 years) of nuclear waste. Or maybe the high-security curtain of the Nevada Test Site provides a convenient screen behind which the DOE can carry out other, more secret projects, under the public relations rubric of a nuclear waste "test" facility. The trail of lies at the DOE, and at its predecessor, the Atomic Energy Commission (AEC), is so long where things nuclear are concerned it is hard to know when to trust the public relations rhetoric and press releases. The more so, since no one without a security clearance (people like the author of this book, for instance) is usually allowed anywhere near these facilities, let alone permitted to actually go underground to poke around to see what is there.[4]

LOS ALAMOS, NEW MEXICO -- At a June 1983 scientific conference in Lake Tahoe, the Los Alamos National Laboratory (which is located in northern New Mexico, but run by the University of California) put forward a proposal for a "National Underground Science Facility" to be constructed deep beneath the Nuclear Test Site in southern Nevada. The proposal called for the facility to be built 3,500 ft. underground, with the possibility of extending it as deep as 6,000 ft. Initially, Los Alamos envisioned two experimental test chambers for doing particle physics, gravity experiments and geophysical studies. The facility would also include machine and electronic shops, a small computer, and dormitory space.[5] Whether or not this installation was built I do not know. But, even if it wasn't, the fact that a government agency was actively planning to go as far down as 6,000 ft. to construct a manned scientific facility gives an idea of how deeply based these underground installations can be. Most of the underground facilities I identify in this book range anywhere from tens to hundreds of feet underground. However, it is quite possible that there are bases that are thousands of feet

underground. *Researchers and students of this subject should be prepared to think of bases located as much as a mile or more beneath the surface.* That may seem implausibly deep, but I promise the reader that at the Pentagon there are planners who have commissioned studies calling for military bases to be built as deep underground as 8,000 feet below the surface of the earth -- that's over a mile and a half down! Those plans are discussed later in this book.

STANDARD OIL CO. OF NEW JERSEY -- As recently as 1970 Standard Oil Co. of New Jersey operated an emergency center 300 ft. underground in upstate New York, near Hudson. The facility was formerly known as Iron Mountain Atomic Storage. The site contained company records, "vaults, dining halls and more than 50 sleeping rooms for key company officials and their families." [6] More recent reports indicate this facility is now used for storage of corporate records.

NORTHROP -- In the Antelope Valley of southern California, near the towns of Rosamond, Palmdale and Lancaster are three mysterious underground facilities, operated by Northrop, Lockheed and McDonnell Douglas. (See Illustration 19). The Northrop facility is located near the Tehachapi Mountains, 25 miles to the northwest of Lancaster. There are rumors that the installation there goes down as many as 42 levels, and that there are tunnels linking it with other underground facilities in the area. I do not know whether these rumors are true or not. There are also reports of many strange flying objects in the vicinity, of many shapes and sizes. Some are reportedly spherical, others are alleged to be triangular, elongated, boomerang or disk shaped. And they are said to range in size up to hundreds of feet in diameter. The facility itself is engaged in electronic or electromagnetic research of some sort. There are large radar or microwave dishes and strange-

looking pylons to which various objects can be affixed, ostensibly for the purpose of beaming electromagnetic radiation at them. These pylons rise up from underground out of diamond-shaped openings in the middle of long, paved surfaces that resemble aircraft runways, but which, in fact, are not used by aircraft.

McDONNELL DOUGLAS -- The McDonnell Douglas facility is located at the now closed Gray Butte airport, northeast of Llano, California. It too has "runways" that are not runways, with diamond-shaped openings through which huge pylons with strangely shaped objects mounted on them are raised to the surface. These objects sometimes resemble elongated disks or flying saucers and have been seen to glow and change colors. Glowing spheres have also been seen by people in the area at night. However, the nature and function of the spheres is not known.

LOCKHEED -- The Lockheed installation is adjacent to what used to be the Hellendale auxiliary airport, six miles to the north of Hellendale, California. Just like the McDonnell Douglas and Northrop facilities it also has the runway-like features, with large, diamond-shaped doors through which huge pylons rise from underground with strange objects attached. This facility also has an obvious underground entrance. (See Illustrations 20 and 21.)

To compound the high strangeness of these California facilities, there are ominous reports of covert military activity associated with them, possible alien activity (and I emphasize possible), possible abductions and lost time episodes, and numerous sightings of extremely unconventional aircraft and flying objects, to which I have already alluded.[7]

AMERICAN TELEPHONE & TELEGRAPH -- A 1981 report revealed that AT&T had seven "emergency centers" in separate regions of the country. At least three of these

were underground complexes. Near Netcong, New Jersey, to the west of New York City, AT&T buried a three-story emergency center in the granite, 40 ft. below ground. In the center were "...executive living quarters, a control room and a computer (with) the data bank for AT&T's entire system." Also in the center were a "kitchen, a month's supply of food for 100 people, sleeping quarters and emergency generators." Facilities like the one at Netcong were also located at Rockdale, Georgia and Fairview, Kansas.[8] And I have been told there are others all over the country, in isolated rural areas. One of these underground AT&T communications facilities is said to be located in Catron County, New Mexico.[9]

In the preceding pages I have set out dozens of known underground facilities, installations and bases. Some of these are quite complex and sophisticated installations, capable of supporting large numbers of people in some degree of comfort. Some are operated by the military, or other branches of government, and some are run by Fortune 500 companies in the military-industrial complex. I have also presented information on dozens of other possible sites where the military was contemplating building deep underground installations.

By now it should be clear that underground bases and installations could literally be just about anywhere: under a military base; under a major hotel; under a prominent government building; under old, abandoned mine workings; under virtually any mountain or hill; under a national park, or perhaps in a national forest; in a small town; or in the middle of a large city -- maybe even deep under an Alaskan glacier. And as the Army Corps of Engineers documents spell out, these underground facilities could be -- and in many cases probably are -- well

camouflaged and concealed, making detection by a casual observer difficult.

The purpose and function of many of these facilities appear to be related to either the waging or the surviving of nuclear war -- or both. Of course, many other agendas and projects could conceivably be carried out in these underground installations as well. Let your mind run -- secret scientific research? Super-secure prisons where people are secretly detained incommunicado? Extraterrestrial living areas?

I must confess that while I don't have many answers, at the least it does seem certain that the southern California Lockeed, Northrop and McDonnell Douglas facilities mentioned above are heavily engaged in nonconventional, hi-tech aerospace research. And while there are stories floating around in UFO circles about bizarre, Nazi-style genetic engineering programs being conducted in underground facilities by "Little Grey" aliens and the U.S. military I can offer no proof that such programs exist. They may exist; they equally may not.

As for the possibility of secret, underground prisons: I will simply observe that many people absolutely disappear in this country every year, never to be heard from again. No bodies are found, no trace of them ever surfaces. I don't know where these people go; I don't know what happens to them. I can offer no proof that any of them are held in secret underground prisons. I cannot even offer any proof that there *are* secret, underground prisons. However, it occurs to me that at the end of WW II many German citizens were surprised to find out that there were concentration camps, run by the Nazis, in which millions of their neighbors (Jews, Gentiles, Gypsies, mentally impaired, homosexuals, political prisoners) had been incarcerated, tortured, forced into slave labor -- and killed.

Given the many underground facilities secretly operated by the U.S. government, could a similar, smaller-scale program be going on here? I have no proof of such a program, but considering the large numbers of disappeared people and the existence of dozens of underground installations operating behind a thick security veil it occurs to me that the possibility is at least conceivable.

As I have shown, there is every reason to think that the underground construction plans and activities of the military continued during the 1970s, 1980s and into the 1990s.

A 1974 report by Bechtel Corporation, a huge multinational company that derives significant revenues from government contract work, stated that, "The demand for tunneling and underground excavation for national defense needs is believed to be large. Some examples of underground defense facilities include: hard-rock silos, command posts, communications systems, personnel shelters, storage and power generation facilities."[10]

And a 1981 report issued by the U.S. National Committee on Tunneling Technology made a similar point: "The demand for defense-related underground construction will be affected significantly by decisions made in the early 1980s. It could be for as much as 20 million cubic meters for missile sites and underground command posts, most of which would be constructed between 1985 and 1995. These projects do not include the civil construction routinely carried out by the (Army) Corps of Engineers."[11]

In other words, there could easily be a lot of covert construction going on beneath our feet right now.

Chapter Five
THE MOTHER OF ALL UNDERGROUND TUNNELS?

In UFOlogy, stories of secret, deep-underground tunnel systems, and the hi-tech tunnel boring machines that make them, are often heard in connection with sensational stories of secret, underground bases that are jointly "manned" (is that the right word?) by those pesky aliens known as the "Little Greys" and covert elements of the military-industrial complex. I don't know whether the Little Greys are real or not. Nor do I know whether the alleged tunnel systems are real or not.

But, I do know that the United States military had extensive plans in the 1980s to construct a very deep, hundreds-of-miles-long, underground tunnel system somewhere in the western United States.

And in 1968 The Office of High Speed Ground Transportation of the United States Department of Transportation (DOT) drew up plans for a very deep underground tunnel system in the Northeast. This system was to have run between Washington, DC and Boston, Massachusetts. This chapter explores both the military and the DOT tunnel system plans.

Before presenting the documentation on these projects, I'd like to say that I don't reject out of hand the possibility of secret, underground tunnel systems. Far from it. In fact, based on much research and many conversations, I think there may very easily be secret tunnel

systems, deep underground, that may be quite lengthy. But since I cannot rigorously document their existence, I will restrict the discussion to a presentation of what *can* be documented -- U.S. government *plans* for deep underground, elaborate tunnel systems.

U.S. National Committee on Tunneling Technology -- and Pentagon Plans for a Deeply Based Missile Tunnel System

In 1972 the Chairman of the Federal Council for Science and Technology asked the Presidents of the National Academy of Sciences and the National Academy of Engineering to establish a U.S. National Committee on Tunneling Technology (USNC/TT). The committee was then formed by the Governing Board of the National Research Council.

The committee functions as the "United States focal agency in the field of tunneling technology, to assess and stimulate improvements in tunneling technology applications, and to coordinate U.S. tunneling technology activities with those of other nations." Its members are drawn from a wide variety of federal, state and local government agencies; from academic departments in universities; and from private industry, labor organizations and consulting firms. In 1977 the USNC/TT had the following subcommittees:

a) Management of Major Underground Construction
 Projects
b) Deep Cavity and Tunnel Support Systems
c) On Site Investigation
d) Demand Forecasting
e) Education and Training
f) Contracting Practices[1]

Deep Underground Tunnel Plans

In 1981 and 1982 the USNC/TT sponsored a special project called "Workshop on Technology for the Design and Construction of Deep Underground Defense Facilities."[2] The project was sponsored by the U.S. Bureau of Mines under contract no. JO 199025. Co-sponsoring agencies with the Bureau of Mines were the U.S. Geological Survey, Bureau of Reclamation, Defense Nuclear Agency, Department of the Air Force, Department of the Army, Department of the Navy, Department of Energy, National Science Foundation, Federal Highway Administration and the Urban Mass Transportation Administration. The workshop was called at the request of the Defense Nuclear Agency to plan for the construction of a deeply based nuclear missile system. The moderator of the workshop was Edward J. Cording, of the Department of Civil Engineering, University of Illinois at Urbana and then chairman of the USNC/TT. Work groups were formed for Siting; The Use of Existing Underground Space; Egress; Mechanical Mining; Construction Planning; and Management, Contracting, Costing, and Personnel. The select roster of participants included dozens of professionals, including private consultants and consulting firms from many states; public utilities such as Pacific Gas & Electric Co.; universities such as Cornell, Stanford, Pennsylvania State and the Colorado School of Mines; and even a union (Local 147 of the Compressed Air and Free Air Tunnel Workers).

According to reports issued by the USNC/TT in 1982, the planners assumed that 400 miles of tunnels ranging from 2,500 to 3,500 ft. underground would need to be constructed to connect the deep bases that would house MX nuclear missiles. The tunnels would be 16 ft. in diameter, "with access shafts, interconnecting passageways,

and adits for storage, living quarters and other needs." (An adit is either a horizontal passageway, an entrance, or an approach).

Electric power would be obtained from either fuel cells or nuclear reactors. Spare tunnel boring machines would also be stored in the tunnel sytem. The plan mentioned deep underground shops for the complete repair of tunnel boring machines. There were to be special tunnel boring machines for digging out from deep underground after a nuclear attack, so that reserve nuclear missiles stored thousands of feet underground could be fired in retaliation.

In the event of war, the base would be sealed off and power for the underground system of tunnels, tunnel boring machine repair shops, crew quarters and missile nests would need to be internally generated. Boeing Aerospace Company published the results of a study in 1984 that set forth plans for power generation in a sealed, deep ICBM base.

After examining several options, Boeing decided that iron-chlorine fuel cells would be the most efficient way to generate electricity. In this power-generation scheme huge, underground tanks store liquid chlorine that is combined with hydrogen to form hydrochloric acid (HCL). This chemical reaction generates electricity. The HCL is then pumped into huge tanks filled with small iron balls; the iron (Fe) and HCL react chemically to form ferrous chloride ($FeCl_2$) and release hydrogen gas, which is then pumped back to the fuel cell to react again with the liquid chlorine, starting the whole cycle over. Iron-chlorine fuel cells are the preferred mode of power generation if the post-attack confinement of the base lasts for less than four years.

If the base were to be sealed for more than four years, however, financial cost-benefit analysis indicated that

liquid-metal-cooled nuclear reactors would be recommended over iron-chlorine fuel cells. The report does not say, but based on other literature I have seen the liquid-metal used to cool the liquid-metal-cooled reactors would probably be lithium.[3]

The USNC/TT tunnel plan called for the system to be built in the late 1980s and early 1990s, with "mobilization" of manpower and resources beginning in the early 1980s. The probable tunnel boring machine (TBM) supplier for the project indicated that it could supply "two machines between January and June 1985, one machine per month between July and December 1985, two machines per month between January and June 1986, and three to four machines per month thereafter." That supply schedule was predicated on using a 16 ft. tunnel diameter. If 18 ft. were selected as the diameter, the manufacturer was able to make available 8 to 10 second-hand TBMs that could be reconditioned for immediate service.[4]

The report includes artists' conceptions of how portions of a deeply based missile tunnel system might look (See Illustrations 22-24). Where might this system be located, assuming it has already been built, or is now under construction?

The planners assumed it would be built somewhere in the western third of the country (See Illustration 27). Three specific sites mentioned in the text of the report are (a) Forty-Mile Canyon in Nevada; (b) Grand Mesa, Colorado; and (c) the basalt plain in the Columbia River Basin, near Fairchild Air Force Base in the State of Washington.

There are other federal documents and press reports which explicitly discuss this deep underground tunnel system. In August 1980, the Air Force released a detailed, two-volume study which was prepared by the School of

Mines, in Golden, Colorado. The study is entitled, *"Tunnel Boring Machine Technology for a Deeply Based Missile System."*[5] It calls for a 480 km long (about 300 miles), deep underground tunnel system that would connect "missile nests" 2400 ft. or more underground. In the event of nuclear war, the plans call for military crews to operate mechanical, tunnel boring machines that would bore up to the surface from bases half a mile or more underground, towing nuclear missiles behind them, which they would then fire at the enemy (See Illustrations 25 and 26 for schematic diagrams of the egress tunnel boring machine designs, and missile egress plans from deep underground). The tunnel boring machine companies mentioned in the report are The Robbins Company, of Kent, Washington and Jarva Inc., of Solon, Ohio. Morrison Knudsen, of Boise, Idaho (a huge company with subsidiaries in many states) is mentioned as a construction consultant.

There are many other documents and articles that detail these plans. In 1984 *The New York Times* ran a front page story that described the planned, underground missile base as something like a "400-mile network of subways that would be 2,500 to 3,500 feet below the surface, probably in a desert in the western United States."[6] In 1985 the *Asian Defence Journal* ran an almost identical story.[7]

A highly technical 1985 document from the Air Force Geophysics Laboratory discusses ground motion effects that a deep underground facility might experience were it to undergo nuclear attack. In particular, it refers to an "underground missile base within Generic Mountain B in the ICBM Basing Construction Planning Study."[8] Unfortunately, no specific location or layout for the missile base is mentioned.

A 1985 report from the Army Corps of Engineers Omaha District explicitly refers to an "ICBM deep basing

construction planning study." [9] Another, 1988 report by the U.S. National Committee on Tunneling Technology and the U.S. National Committee for Rock Mechanics discussed an underground missile system ranging between 3,000 ft. and 8,000 ft. underground.

That's right -- *as much as 8,000 ft. underground.*

This 1988 report mentions having the base operational as soon as possible, "within a five-year construction schedule." Five years from 1988 is 1993. Is such a base now operational, far below some unknown location in the United States? Based on my research, I am not certain. However, given the rather substantial paper trail, it is certainly within the realm of possibility that something like it has been secretly built.

The 1988 report calls for a system with tunnels up to 20 miles long, branching off from access shafts. The report's conclusion states, "The consensus of the working groups involved in preparing this report is that the basic technical capabilities to create complex underground facilities at the pace and depth envisioned are available in current practice."[10]

A series of federal contracts for development of the deep underground missile system were let in the mid-1980s by the Air Force's Ballistic Missile Office, at Norton Air Force Base, in California. The contracts that were let do not, in and of themselves, prove that the project has actually been carried out. At the least, though, they do demonstrate that this concept went well beyond a paper, planning stage and began to develop real, hard technology.

United Technologies, Hamilton Standard Division, of Windsor Locks, Connecticut was given a contract in November 1985 for "life support and chemical/biological agent mitigation systems on the Small Intercontinental

Ballsistic Missile (ICBM) Deep Basing Program." The projected completion date for the work was February 1988. The Federal Contract No. was: F04704-85-C-0111.[11] This contract would probably have to do with supply of pure air and water for the crew(s) of an underground base.

In December 1985, BDM of McLean, Virginia was awarded a contract to conduct an "intercontinental ballistic missile (ICBM) deep basing communication study." The contract was to be completed by February 1988; the Federal Contract No. was: F04704-86-C-0045.[12]

In 1986 Bell Aerospace Textron was given a contract for an "ICBM deep basing gas propelled launcher feasibility demonstration." Plans called for completion of the contract by June 1988. The Federal Contract No. was: F04704-86-C-0100.[13] The wording of the contract announcement creates the image of a nuclear missile being ejected into flight from the mouth of a tunnel bored to the surface from deep underground.

In 1987 Earth Technology, of San Bernardino, California was awarded a multi-million dollar increase to a previously awarded contract, in order to carry out what the Department of Defense rather fuzzily referred to as "geotechnical and siting deep basing fine screening Phase I and II."[14] In ordinary language this would seem to mean that the Ballistic Missile Office paid this company millions of dollars to do a two-phase geological and technical study, to fine screen sites where a deep underground missile base would be located. The Federal Contract No. was: F04704-85-C-0084.

And finally, the Robbins Company, of Kent, Washington (the tunnel boring machine manufacturer mentioned in the Air Force Weapons Laboratory/Colorado School of Mines two-volume report mentioned above) was awarded a contract in 1985 for "egress/excavation

development and testing."[15] Presumably, this refers to excavation for egress of nuclear missiles from deep underground, since the contract was let by the Ballistic Missile Office at Norton Air Force Base. The Federal Contract No. was: F04704-85-C-0112.

So is there really a secret, military tunnel system? The short answer to this question is: I am not certain.

But the documents, articles and contracts referred to above suggest it is entirely possible that the military, working through the Ballistic Missile Office at Norton Air Force Base, with the probable assistance of the Army Corps of Engineers and private companies such as Robbins, Earth Technology, and others, has secretly built an extensive, very deeply buried tunnel system and nuclear missile complex, somewhere in the United States, perhaps somewhere in the West.

If it has been made, this system may be, in its totality, hundreds of miles long and thousands of feet underground. If it exists it is certainly very well hidden. And if it exists it may very well explain either partly or wholly the recurrent rumors in UFOlogy about a secret tunnel system in the southwestern United States. But even if it has not been built, the extensive plans, studies, and various contracts referred to above would be sufficient to fuel rumors about the existence of such a tunnel system.

From the standpoint of disinformation there is another possibility: that the military has really built a tunnel system of the sort described here, but has tried to hide its existence under a tabloid-style cover story of alien tunneling activities. According to this hypothetical scenario the military would count on the "alien" connection to be sufficiently ridiculous in the public eye that if word of the tunnels ever surfaced in the media they could be discounted as the fevered imaginings of daffy UFOlogists

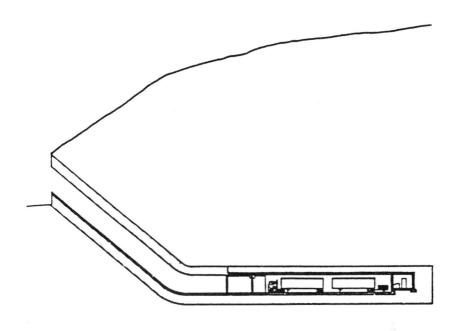

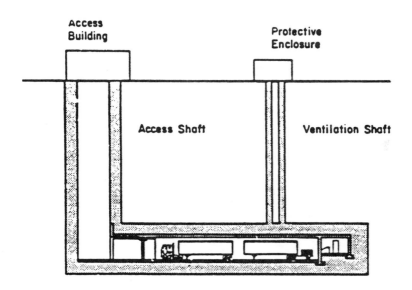

Access Building

Protective Enclosure

Access Shaft

Ventilation Shaft

ILLUSTRATION 1 - Even though hidden from public view behind layers of high security, entrances to underground bases neverthless can be big enough to literally drive a truck into. Two means of approach are shown here. *Source: U.S. Army Corps of Engineers, Literature Survey of Underground Construction Methods for Application to Hardened Facilities.*

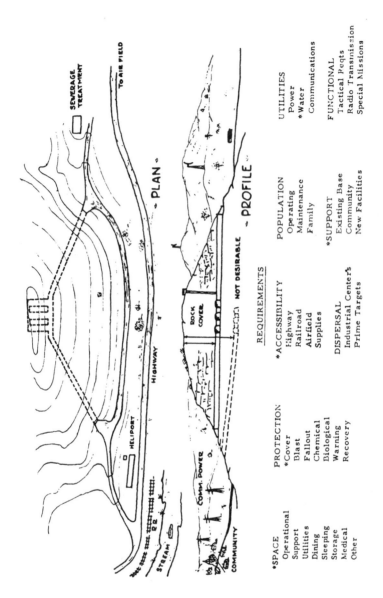

Underground site plan and requirements

ILLUSTRATION 2 - Example of Army Corps of Engineers plan for an underground base, circa late 1950s. Notice the microwave towers for communication and planned proximity to a community, highway, railroad tracks and power lines. Note, too, that two entrances are preferred and that there is a vertical shaft to the surface as well, perhaps for air. *Source: M.D. Kirkpatrick, in Protective Construction in a Nuclear Age: Proceedings of the 2nd Protective Construction Symposium, 24-26 March 1959, Vol. I, ed. J.J. O'Sullivan (New York: The Macmillan Co., 1961).*

Illustration 3 - There is an underground facility beneath this ridge in the Manzano foothills on the outskirts of Albuquerque, New Mexico. This underground installation, begun in the late 1940s, is on Kirtland Air Force Base. *Photo by the author.*

ILLUSTRATION 4 - An underground chamber in the mysterious Los Alamos Lab facility, circa 1940s. After repeated requests, the Department of Energy released a badly blurred photostatic copy of a magazine article that included this photograph. See Pages 27-30 for the whole story. *Original publication unknown.*

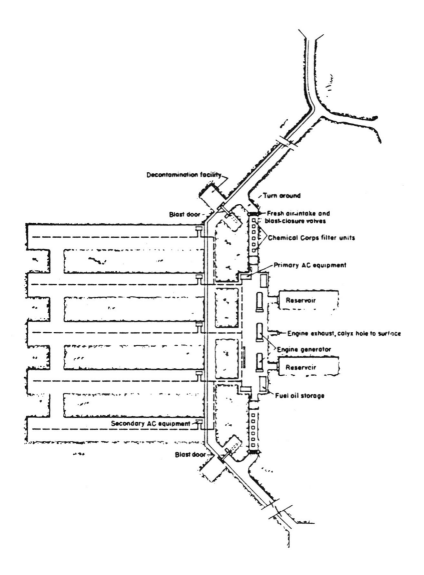

Decontamination facility
Turn around
Blast door
Fresh air intake and blast-closure valves
Chemical Corps filter units
Primary AC equipment
Reservoir
Engine exhaust, calyx hole to surface
Engine generator
Reservoir
Fuel oil storage
Secondary AC equipment
Blast door

Example of underground plant arrangement

ILLUSTRATION 5 - Even in the 1950s, military planning for sizeable underground installations was in full swing. Note the decontamination room, the chemical filter units, the blast closure valves on the fresh air intake units, and the water reservoirs.
From U.S. Army Corps of Engineers, <u>Design of Underground Installations in Rock: Protective Features and Utilities</u>.

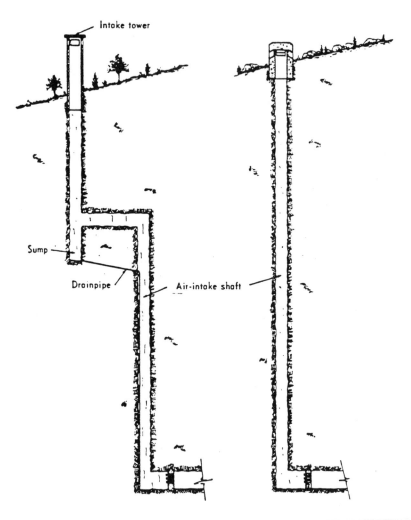

Example of air-intake shafts

ILLUSTRATION 6 - Two ways of protecting the fresh air intake from above ground, circa 1950s. *From U.S. Army Corps of Engineers, Design of Underground Installations in Rock: Protective Features and Utilities.*

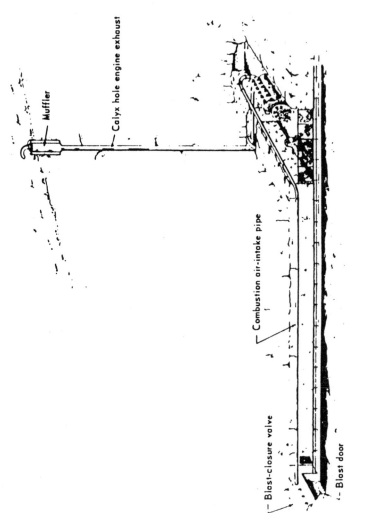

ILLUSTRATION 7 - Machinery powered by internal-combustion engines under-ground would use up valuable breathing air, so the military planners in the 1950s devised a way to supply air to the machines, and exhaust the fumes. *Source: U.S. Army Corps of Engineers, Design of Underground Installations in Rock: Protective Features and Utilities.*

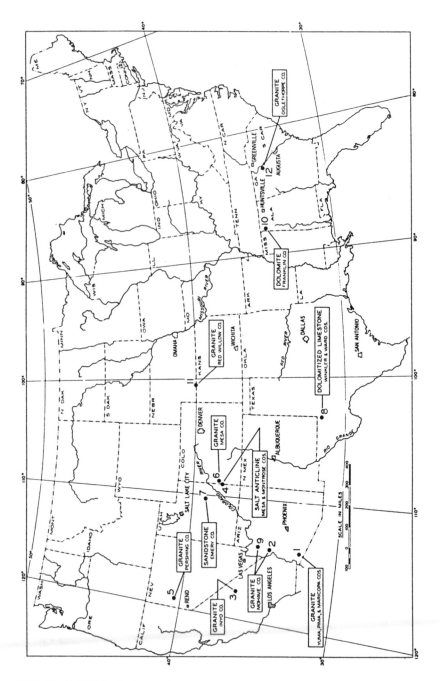

ILLUSTRATION 8 - In 1964, the Army Corps of Engineers picked 12 sites suitable for the construction of 600-ft. diameter cavities 4,000 ft. underground, for the purpose of setting off nuclear bomb test explosions. *Source: U.S. Army Corps of Engineers, Feasibility of Constructing Large Underground Cavities, Vol. I.*

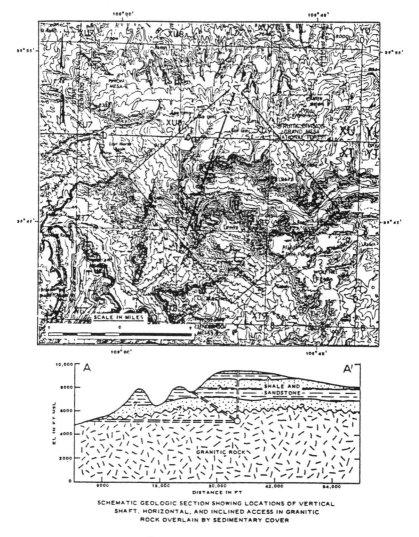

SCHEMATIC GEOLOGIC SECTION SHOWING LOCATIONS OF VERTICAL
SHAFT, HORIZONTAL, AND INCLINED ACCESS IN GRANITIC
ROCK OVERLAIN BY SEDIMENTARY COVER

Site 6, granite with sedimentary cover,
Mesa County, Colorado

ILLUSTRATION 9 - One of the sites selected by the U.S. Army Corps of Engineers
in 1964, suitable for constructing a large cavity, deep underground, for testing
nuclear bombs. Note that the horizontal option for access takes the form of a tunnel
miles long. *Source: U.S. Army Corps of Engineers, Feasibility of Constructing Large Underground
Cavities, Vol. I.*

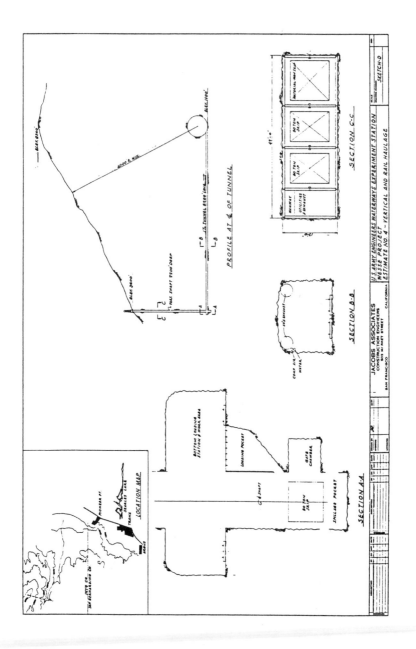

ILLUSTRATION 10 - A 1964 plan from the Army Corps of Engineers to construct a large underground cavity 4,000 feet underneath Argus Peak, northwest of Trona, California. If built, this facility would today be within the boundaries of the China Lake Naval Weapons Center, which has long been rumored to be the site of a massive underground installation. *Source: U.S. Army Corps of Engineers, Feasibility of Constructing Large Underground Cavities, Vol. III.*

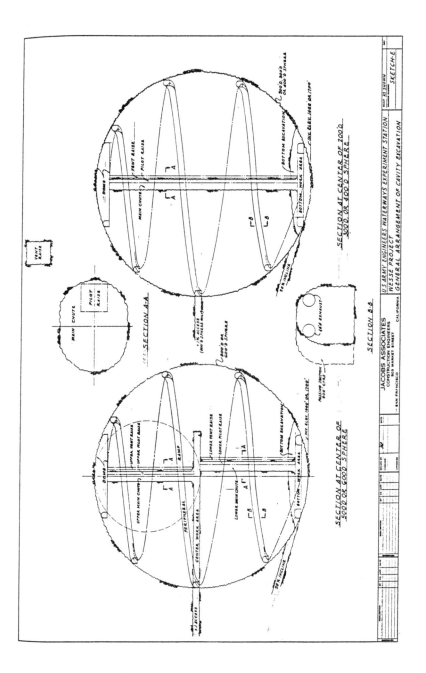

ILLUSTRATION 11 - A beautiful piece of drafting work from the Army Corps of Engineers, circa 1964. Was this facility, proposed for construction within the boundaries of present-day China Lake Naval Weapons Center, northwest of Trona, California, ever built? *Source: U.S. Army Corps of Engineers, Feasibility of Constructing Large Underground Cavities, Vol. III.*

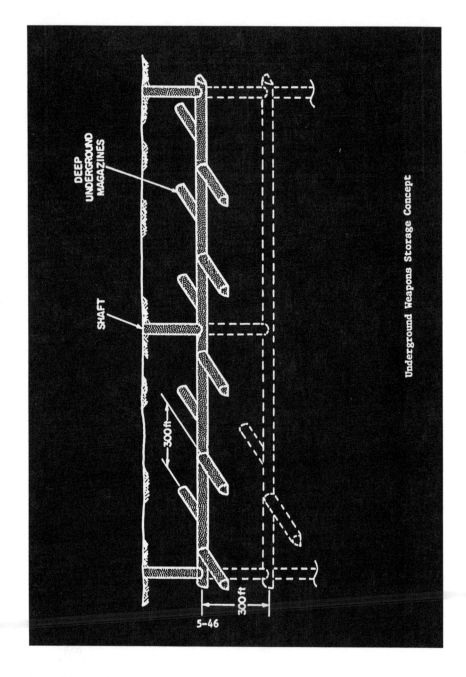

ILLUSTRATION 12 - You'd think the Navy would stick to the water, but no -- they have plans to dig underground, too. Here they're figuring out how to store and hide their weapons. *Source: R. Hibbard, et. al., <u>Subsurface Deployment of Naval Facilities</u>, 1972.*

ILLUSTRATION 13 - The Nevada Test Site, shown here in an official Department of Energy photo taken in 1980, at the time of a less than 20-kiloton nuclear bomb test that took place 1,280 feet beneath Rainier Mesa. The test, designed by the Los Alamos National Laboratory, was conducted for the U.S. Defense Nuclear Agency. There are three underground entrances visible; one is large enough to receive a train. The numerous parked trucks are reminders of the large numbers of people who work underground. They're not likely, though, to discuss their work with you: the secrecy oaths that they sign are very intimidating. *Department of Energy photo.*

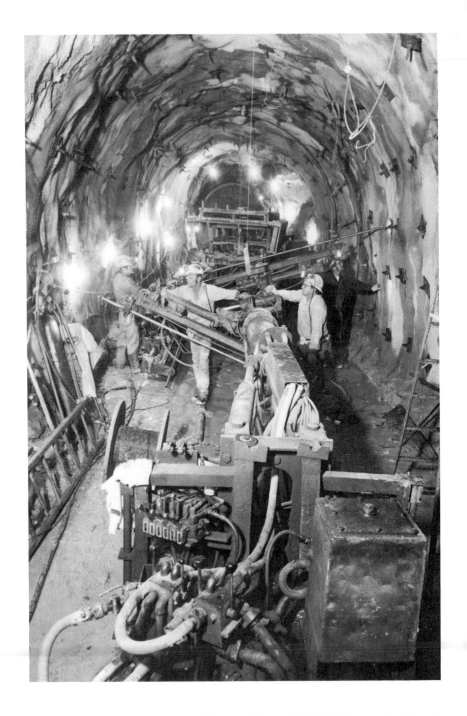

ILLUSTRATION 14 - Miners at work in tunnels beneath Rainier Mesa at the Nevada Test Site. They're stabilizing the walls with rock bolts and epoxy so that when the nuclear explosions go off, the walls won't crumble. *Department of Energy photo.*

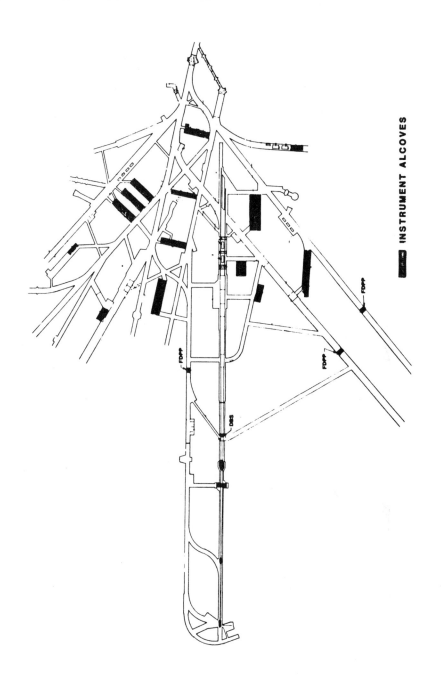

INSTRUMENT ALCOVES

ILLUSTRATION 15 - A partial map of "N" Tunnel, just one of the many tunnel complexes at the Nevada Test Site. Most of the black boxes are instrument alcoves. This labyrinth of passageways and tunnels -- and it's only a fragment of the whole -- reveals how much time and energy has been spent underground by just part of just one government agency at just one site. *Department of Energy photo.*

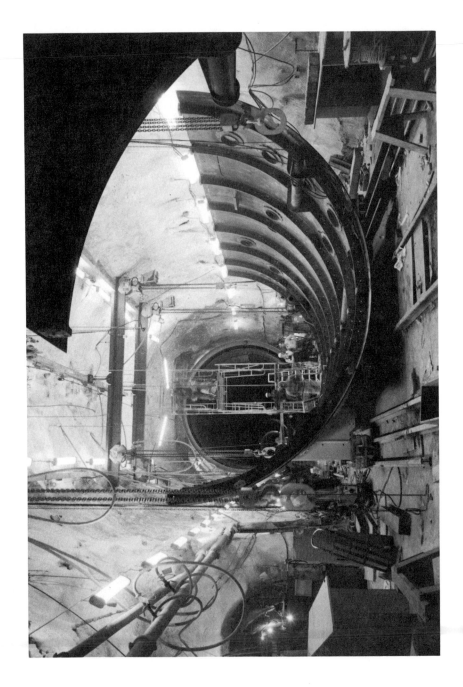

ILLUSTRATION 16 - A "line-of-sight" pipe under construction under Rainier Mesa at the Nevada Test Site. These pipes, which can be up to 27 ft. in diameter, serve as test chambers that house monitoring equipment. They are placed 900 to 2,000 ft. from the nuclear blast. *Defense Nuclear Agency photo.*

ILLUSTRATION 17 - Construction of nuclear test monitoring chambers in a tunnel under Rainier Mesa, at the Nevada Test Site. *Department of Energy photo.*

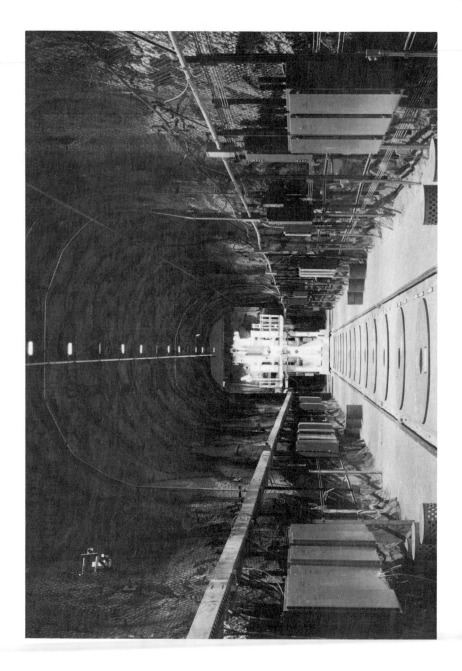

ILLUSTRATION 18 - The one problem -- and it's a big one -- that the nuclear industry has not yet solved is what to do with nuclear waste. This test, run from 1980-83 at the Nevada Test Site, evaluated the effects of storing spent reactor fuel in a granite formation, 1,400 ft. underground. The spent nuclear fuel elements are in steel-lined holes in the floor, capped by 5,000 lb. concrete plugs. *Department of Energy photo.*

ILLUSTRATION 19 - Local maps for finding the Northrop and McDonnell Douglas facilities in the Antelope Valley of Southern California.The Northrop facility is rumored to have as many as 42 underground levels. These plants feature strange installations not unlike the photographs from the Lockheed Plant in Hellendale, California (See Illustrations 20 and 21). This whole area is reported to be a great place to spot very unconventional aircraft. *This illustration reprinted with permission from the November 1992 HUFON Report, the newsletter of the Houston UFO Network, PO Box 942, Bellaire, TX 77402 (713)850-1352.*

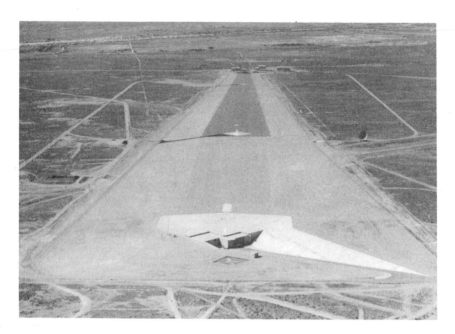

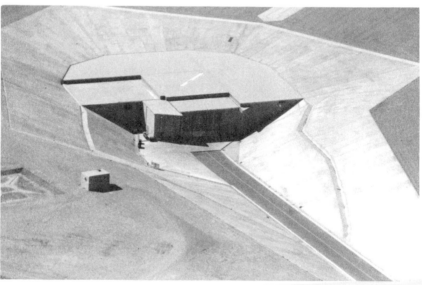

ILLUSTRATION 20 - Lockheed's mysterious Hellendale, California facility. The underground entrance (shown in close-up in lower photo) is in foreground. Although the long paved surface would seem to be a landing strip, it is interrupted by two huge pylons, which serve to render this "landing strip" unusable for conventional fixed-wing aircraft. *Photos collection of the author.*

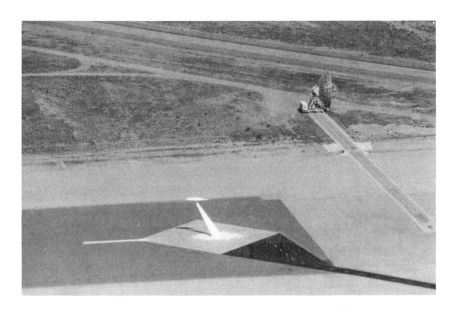

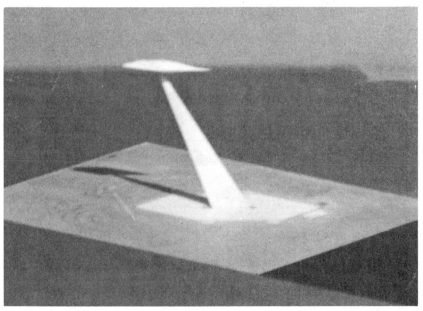

ILLUSTRATION 21 - Long shot and close-up view of unknown object on a test pylon at Lockheed's Hellendale, California facility. The pylon can be lowered into an underground chamber until it disappears from view (the white area around its base are doors which open and close). Some reports say that this is a radar testing facility, and the antenna dish bounces radar waves off test objects. *Photos collection of the author.*

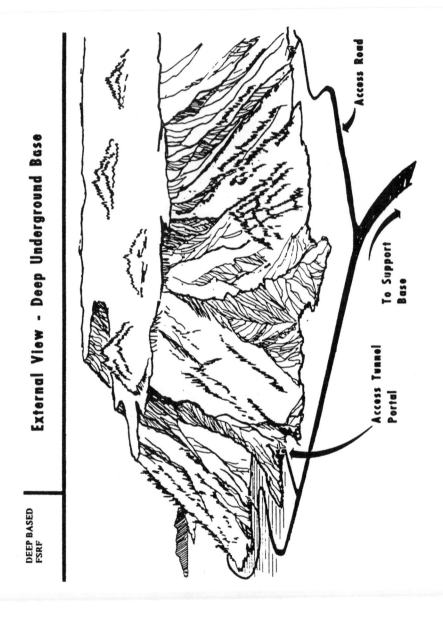

External View - Deep Underground Base

DEEP BASED
FSRF

Access Road

To Support
Base

Access Tunnel
Portal

ILLUSTRATION 22 - A 1982 report from the U.S. National Committee on Tunneling Technology contained this picture of what a deep underground base for strategic missiles would look like -- from the outside. *Source: Design and Construction of Deep Underground Basing Facilities for Strategic Missiles, Vol. 2, Briefings on Systems Concepts and Requirements,* Fed. Doc. No. NRC/CETS/TT-82-2.

ILLUSTRATION 23 - Cutaway view of a deep underground base. Note the pre-dug exits for possible missile launchers. *Source: Design and Construction of Deep Underground Basing Facilities for Strategic Missiles, Vol. 2, Briefings on Systems Concepts and Requirements, Fed. Doc. No. NRC/CETS/TT-82-2.*

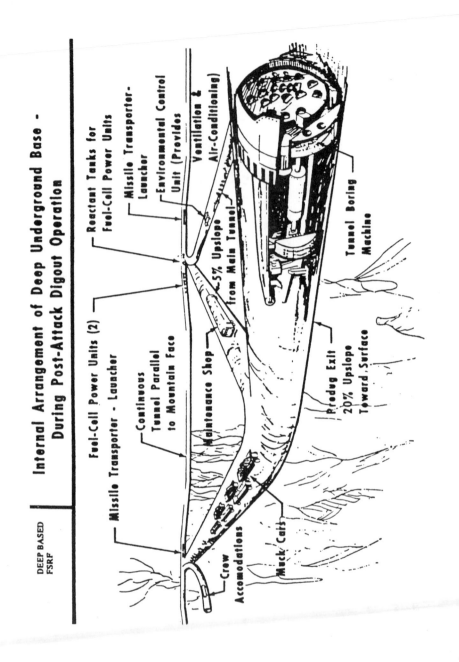

Internal Arrangement of Deep Underground Base - During Post-Attack Digout Operation

DEEP BASED FSRF

Fuel-Cell Power Units (2)

Missile Transporter - Launcher

Reactant Tanks for Fuel-Cell Power Units

Missile Transporter - Launcher

Environmental Control Unit (Provides Ventilation & Air-Conditioning)

Continuous Tunnel Parallel to Mountain Face

~5% Upslope from Main Tunnel

Maintenance Shop

Tunnel Boring Machine

Pre-dug Exit 20% Upslope Toward Surface

Crew Accomodations

Muck Cars

ILLUSTRATION 24 - The tunnel boring machine (TBM) inside the pre-dug exit goes into action and bores the rest of the way out from deep underground. In this representation, the missile transporter and launcher are in the background. *Source: Design and Construction of Deep Underground Basing Facilities for Strategic Missiles, Vol. 2, Briefings on Systems Concepts and Requirements, Fed. Doc. No. NRC/CETS/TT-82-2.*

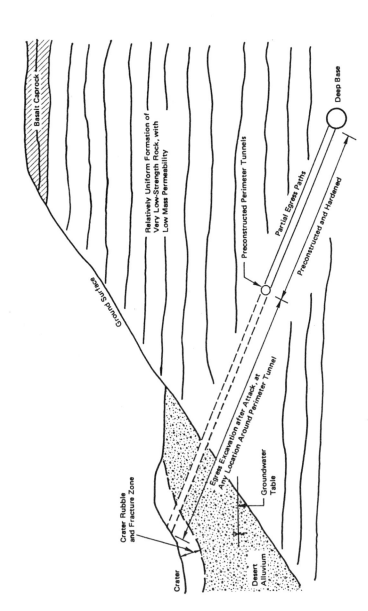

ILLUSTRATION 25 - Here's a side view of the post-attack dig-out tunnel. *Source: Design and Construction of Deep Underground Basing Facilities for Strategic Missiles, Vol. 1, Evaluation of Technical Issues, Fed. Doc. No. NRC/CETS/TT-82-1.*

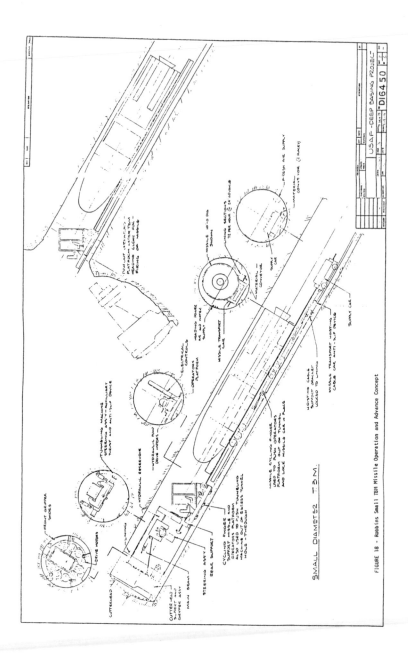

ILLUSTRATION 26 - Here's a detailed schematic from the Air Force for a combination tunnel-boring machine and nuclear missile launcher that would be used to dig out of a deep underground missile base and fire a missile. The deep base would be at least a half mile underground. *Source: Tunnel boring Machine Technology for a Deeply Based Missile System, Vol. 1, Pt. 1, Application Feasibility, Fed. Tech. Doc. No. AFWL-TR-79-120 (August 1980).*

Potential Geologically Suitable Areas

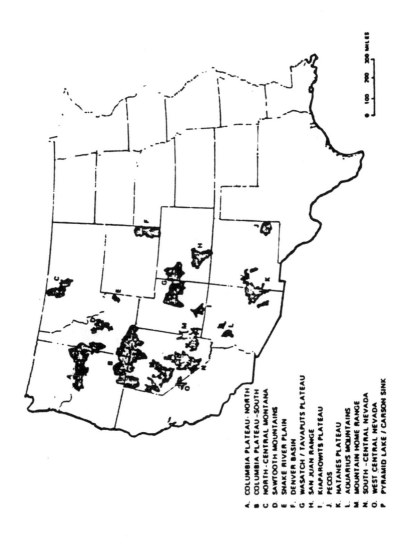

A. COLUMBIA PLATEAU - NORTH
B. COLUMBIA PLATEAU - SOUTH
C. NORTH - CENTRAL MONTANA
D. SAWTOOTH MOUNTAINS
E. SNAKE RIVER PLAIN
F. DENVER BASIN
G. WASATCH / TAVAPUTS PLATEAU
H. SAN JUAN RANGE
I. KIAPAROWITS PLATEAU
J. PECOS
K. MATANES PLATEAU
L. AQUARIUS MOUNTAINS
M. MOUNTAIN HOME RANGE
N. SOUTH - CENTRAL NEVADA
O. WEST CENTRAL NEVADA
P. PYRAMID LAKE / CARSON SINK

0 100 200 300 MILES

ILLUSTRATION 27 - The government identified these 16 spots as potential sites for
deep underground basing facilities for strategic nuclear missiles. *Source: Design and
Construction of Deep Underground Basing Facilities for Strategic Missiles, Vol. 2, Briefings on Systems
Concepts and Requirements, Fed. Doc. No. NRC/CETS/TT-82-2.*

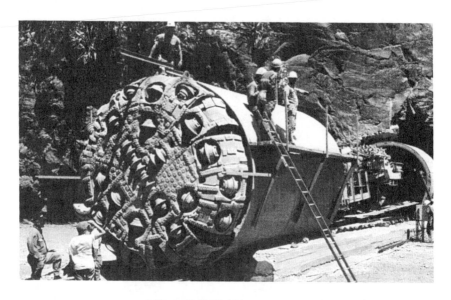

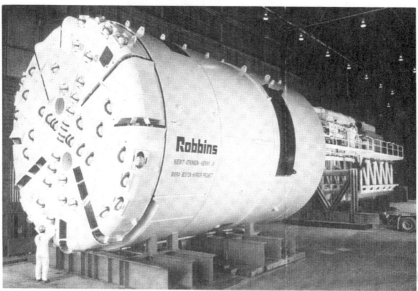

ILLUSTRATION 28 - Two tunnel boring machines (TBMs) sold by The Robbins Company. The top model was built for La Reunion irrigation project; the bottom one for Boston Outfall. The front ends of these TBMs chew away the rock; the structures that trail behind house the operators and carry away the muck. *Photos used with permission from The Robbins Company.*

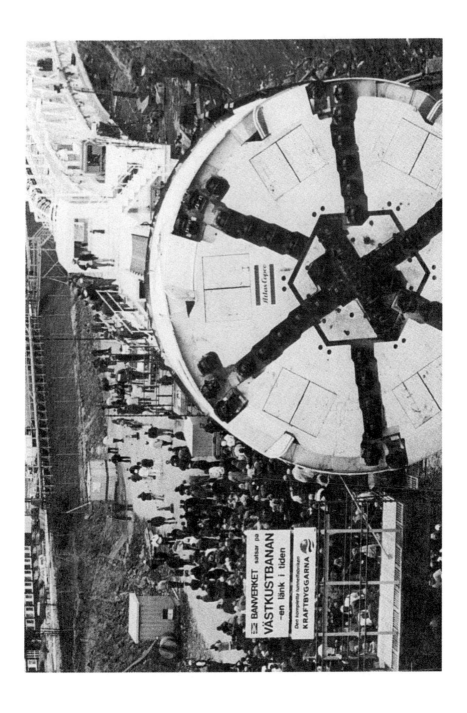

ILLUSTRATION 29 - This Jarva MK27 model was used to build the Hallandsås rail tunnel in Sweden. *Photo used with permission from The Robbins Company.*

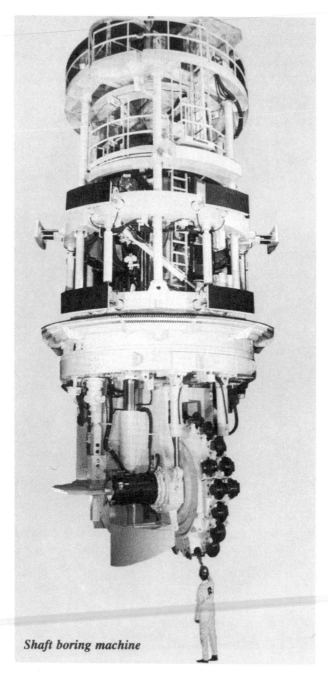

Shaft boring machine

ILLUSTRATION 30 - The Robbins Company manufactures huge shaft-boring machines for excavating large vertical shafts. *Photo used with permission from The Robbins Company.*

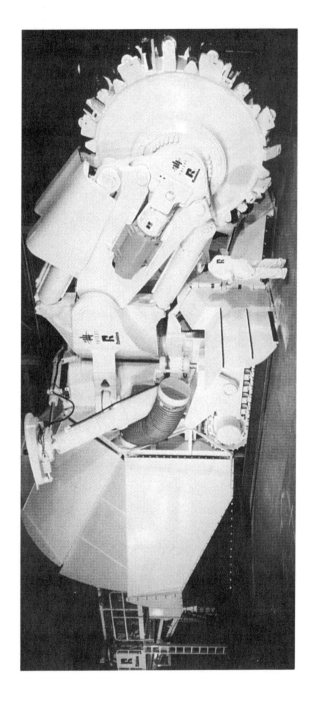

ILLUSTRATION 31 - This Mobile Miner, sold by The Robbins Company, cuts a large D-shaped tunnel. *Photo used with permission from The Robbins Company.*

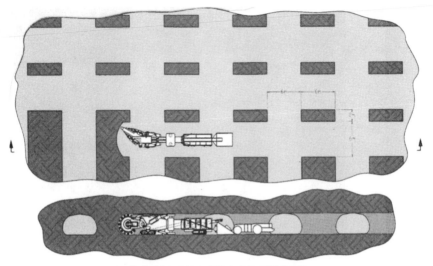

ROOM-AND-PILLAR MINING

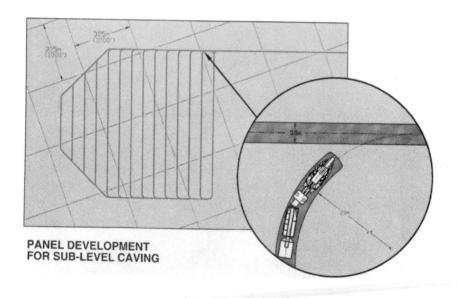

**PANEL DEVELOPMENT
FOR SUB-LEVEL CAVING**

ILLUSTRATION 32 - Depiction of a Robbins Company Mobile Miner in action. The sales literature promises "high advance rates ... " and "... high speed tunneling ..." The large area under excavation in the diagram is amazing; each of the grids in the lower figure is 1,000 ft. on a side. *Photo used with permission from The Robbins Company.*

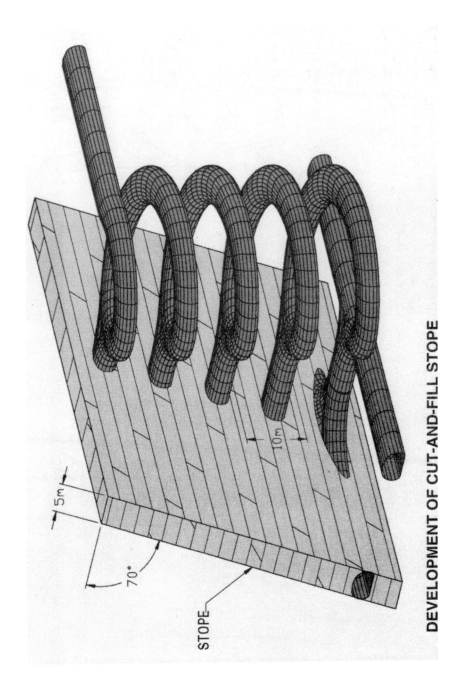

DEVELOPMENT OF CUT-AND-FILL STOPE

10 m

5 m

70°

STOPE

ILLUSTRATION 33 - The Mobile Miner can cut this kind of access tunnel, which is over 15 feet wide. *Photo used with permission from The Robbins Company.*

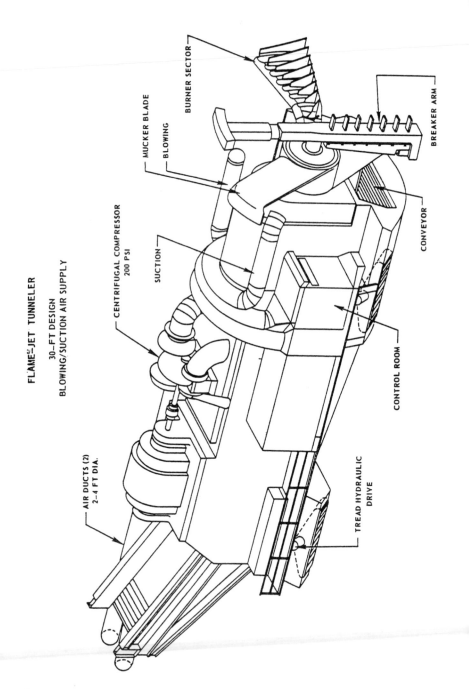

FLAME-JET TUNNELER
30–FT DESIGN
BLOWING/SUCTION AIR SUPPLY

BURNER SECTOR

MUCKER BLADE

BLOWING

BREAKER ARM

CONVEYOR

CENTRIFUGAL COMPRESSOR
200 PSI

SUCTION

CONTROL ROOM

AIR DUCTS (2)
2–4 FT DIA.

TREAD HYDRAULIC
DRIVE

ILLUSTRATION 34 - A Flame Jet Tunneler, as pictured by the U.S. Dept. of Transportation, Office of High Speed Ground Transportation. *From Feasibility of Flame-Jet Tunneling, Volume II - Systems Analysis and Experimental Investigations (May 1968), Fed. Doc. No. PB-178199.*

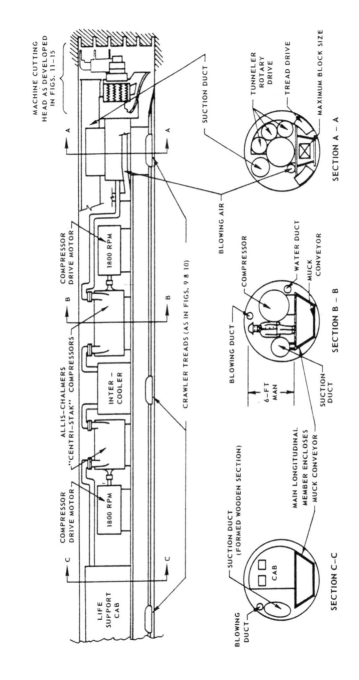

ILLUSTRATION 35 - A Flame Jet Tunneler, as pictured in cross-section by the U.S. Dept. of Transportation, Office of High Speed Ground Transportation. *From Feasibility of Flame-Jet Tunneling, Volume II - Systems Analysis and Experimental Investigations* (May 1968), Fed. Doc. No. PB-178199.

AIR-CONDITIONED CAB

10 MAN DESIGN

AIR FROM MAIN TUNNEL VENTILATION SYSTEM

AIR FLOW TO VENTILATION SYSTEM

AIR CONDITIONER

ICE STORAGE BIN

AIR FLOW TO HEAT REJECTION SYSTEM

AIR LOCK

VENTILATION DUCTS

AIR LOCK PURGE DUCT

ILLUSTRATION 36 - The air-conditioned cab, capacity 10 men, in a Flame Jet Tunneler, as pictured in cross-section by the U.S. Dept. of Transportation, Office of High Speed Ground Transportation. The heat generated by the cutting head of this machine would be intense, judging by the huge ice storage bin, air conditioning, and air lock. From *Feasibility of Flame-Jet Tunneling, Volume II - Systems Analysis and Experimental Investigations* (May 1968), Fed. Doc. No. PB-178199.

HIGH-TEMPERATURE PROTECTIVE-SUIT DESIGNS

FROM REF. 29

a) BACK PACK CONFIGURATION b) UMBILICAL CONFIGURATION

c) COVERALL MATERIAL CROSS SECTION

ILLUSTRATION 37 - Protective suiting for the operators of the Flame Jet Tunnelers. The umbilical cords hook up to an elaborate cooling apparatus (not shown here). *From Feasibility of Flame-Jet Tunneling, Volume II - Systems Analysis and Experimental Investigations (May 1968), Fed. Doc. No. PB-178199.*

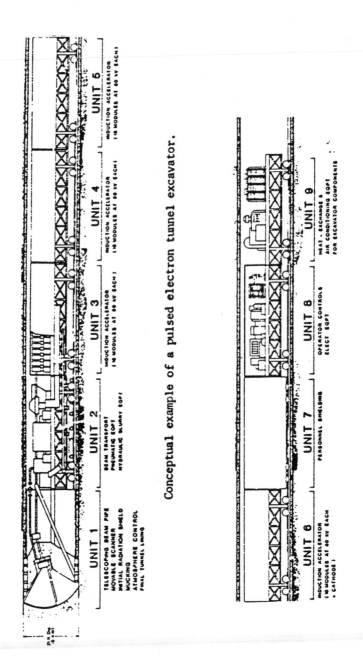

Conceptual example of a pulsed electron tunnel excavator.

UNIT 1
TELESCOPING BEAM PIPE
MOVABLE SCANNER
INITIAL RADIATION SHIELD
MUCKING
ATMOSPHERE CONTROL
FINAL TUNNEL LINING

UNIT 2
BEAM TRANSPORT
PNEUMATIC EQPT
HYDRAULIC SLURRY EQPT

UNIT 3
INDUCTION ACCELERATOR
(18 MODULES AT 80 kV EACH)

UNIT 4
INDUCTION ACCELERATOR
(18 MODULES AT 80 kV EACH)

UNIT 5
INDUCTION ACCELERATOR
(18 MODULES AT 80 kV EACH)

UNIT 6
INDUCTION ACCELERATOR
(18 MODULES AT 80 kV EACH
- CATHODE)

UNIT 7
PERSONNEL SHIELDING

UNIT 8
OPERATOR CONTROLS
ELECT EQPT

UNIT 9
HEAT EXCHANGE &
AIR CONDITIONING EQPT
FOR EXCAVATOR COMPONENTS

ILLUSTRATION 38 - A conceptual drawing of a hard rock tunneling machine that uses pulsed electron beams to cut the rock. To fit this illustration on one page, the drawing was cut between Unit 5 and Unit 6; in the original, the whole machine forms one linked set of cars. *From Accelerator Division Annual Reports, 1 July 1972-31 December 1974, Fed. Doc. No. LBL-3835, UC-28 Particle Accelerators, TID-4500-R62.*

United States Patent

Armstrong et al.

[15] **3,693,731**

[45] **Sept. 26, 1972**

[54] **METHOD AND APPARATUS FOR TUNNELING BY MELTING**

[72] Inventors: Dale E. Armstrong, Santa Fe; Berthus B. McInteer; Robert L. Mills; Robert M. Potter; Eugene S. Robinson; John C. Rowley; Morton C. Smith, all of Los Alamos, N. Mex.

[73] Assignee: The United States of America as represented by the United States Atomic Energy Commission

[22] Filed: Jan. 8, 1971

[21] Appl. No.: 104,872

[52] U.S. Cl.175/11, 175/16, 175/19
[51] Int. Cl. ...E21c 21/00
[58] Field of Search...................................175/11–16

[56] **References Cited**

 UNITED STATES PATENTS

3,396,806 8/1968 Benson175/16 X

3,117,634 1/1964 Persson175/94
1,993,641 3/1935 Aarts et al.175/13
1,898,926 2/1933 Aarts et al.175/16
3,115,194 12/1963 Adams.........................175/11
3,225,843 12/1965 Ortloff....................175/94 X
3,357,505 12/1967 Armstrong et al..........175/16

Primary Examiner—Marvin A. Champion
Assistant Examiner—Richard E. Favreau
Attorney—Roland A. Anderson

[57] **ABSTRACT**

A machine and method for drilling bore holes and tunnels by melting in which a housing is provided for supporting a heat source and a heated end portion and in which the necessary melting heat is delivered to the walls of the end portion at a rate sufficient to melt rock and during operation of which the molten material may be disposed adjacent the boring zone in cracks in the rock and as a vitreous wall lining of the tunnel so formed. The heat source can be electrical or nuclear but for deep drilling is preferably a nuclear reactor.

3 Claims, 7 Drawing Figures

ILLUSTRATION 39 - A nuclear-powered tunneling machine patented by the United States of America, represented by the U.S. Atomic Energy Commission. This tunneler is designed to convert the rock that it excavates into a molten liquid, which fills cracks in the rock, bonds to the walls of the tunnel, and leaves behind a smooth, vitreous lining. The United States Patent Office issued the patent on 26 September 1972.

United States Patent [19]

Altseimer et al.

[11] **3,881,777**

[45] **May 6, 1975**

[54] **APPARATUS AND METHOD FOR LARGE TUNNEL EXCAVATION IN SOFT AND INCOMPETENT ROCK OR GROUND**

[75] Inventors: **John H. Altseimer; Robert J. Hanold,** both of Los Alamos, N. Mex.

[73] Assignee: **The United States of America as represented by the United States Energy Research and Development Administration,** Washington, D.C.

[22] Filed: **Jan. 25, 1974**

[21] Appl. No.: **436,402**

[52] U.S. Cl. 299/33; 175/11; 176/DIG. 3; 299/14
[51] Int. Cl. ... E21c 9/04
[58] Field of Search 299/33, 14; 175/11, 16; 61/45 R

[56] **References Cited**
UNITED STATES PATENTS

3,334,945	8/1967	Bartlett	299/33
3,396,806	8/1968	Benson	175/11
3,667,808	6/1972	Tabor	299/33
3,693,731	9/1972	Armstrong et al.	175/11

Primary Examiner—Frank C. Abbott
Assistant Examiner—William F. Pate, III
Attorney, Agent, or Firm—John A. Horan; Henry Heyman

[57] **ABSTRACT**

A tunneling machine for producing large tunnels in soft rock or wet, clayey, unconsolidated or bouldery earth by simultaneously detaching the tunnel core by thermal melting a boundary kerf into the tunnel face and forming a supporting excavation wall liner by deflecting the molten materials against the excavation walls to provide, when solidified, a continuous wall supporting liner, and detaching the tunnel face circumscribed by the kerf with powered mechanical earth detachment means and in which the heat required for melting the kerf and liner material is provided by a compact nuclear reactor.

The invention described herein was made in the course of, or under a contract with the U. S. ATOMIC ENERGY COMMISSION.

3 Claims, 5 Drawing Figures

ILLUSTRATION 40 - Another nuclear-powered tunneling machine patented by the United States of America, this time represented by the U.S. Energy Research and Development Administration. The United States Patent Office issued the patent papers on 6 May 1975.

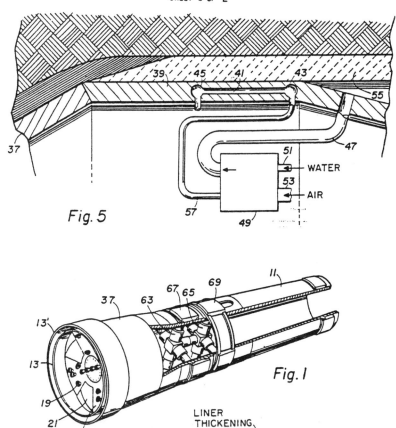

WATER

AIR

Fig. 5

Fig. 1

LINER
THICKENING

PENETRATION → COOLING →

MOLTEN ROCK

SOLID ROCK

GLASS

Fig. 4

COOLING →

PENETRATION CONSOLIDATION

Fig. 3

ILLUSTRATION 41 - Another page of drawings from the 6 May 1975 patent for a nuclear-powered tunneling machine, granted to Los Alamos, New Mexico inventors working for the U.S. Energy Research and Development Administration. This machine would leave behind neat, glass-lined tunnels.

ILLUSTRATION 42 - Two different types of Nuclear Subterrene Tunnel Boring Machines. These machines are designed to melt their way through the rock and soil, leaving behind neat, glass lined tunnels. *Source: Large Suberrene Rock-Melting Tunnel Excavation Systems: A Preliminary Study, Fed. Doc. No. LA-5210-MS.*

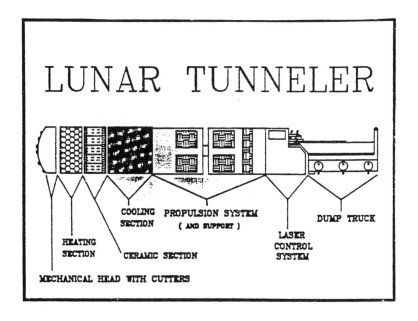

LUNAR TUNNELER

COOLING SECTION
PROPULSION SYSTEM (AND SUPPORT)
DUMP TRUCK
HEATING SECTION
LASER CONTROL SYSTEM
CERAMIC SECTION
MECHANICAL HEAD WITH CUTTERS

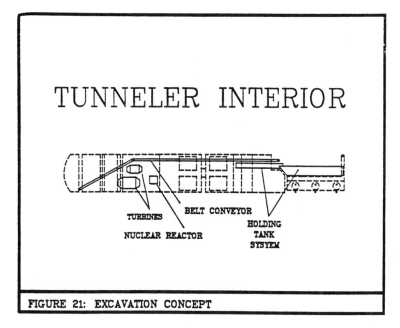

TUNNELER INTERIOR

TURBINES
BELT CONVEYOR
NUCLEAR REACTOR
HOLDING TANK SYSYEM

FIGURE 21: EXCAVATION CONCEPT

ILLUSTRATION 43 - A Lunar Tunneler, as proposed in a project funded by a grant from NASA/USRA. *Reprinted with permission from Proposal for a Lunar Tunnel-boring Machine, by Allen, Cooper, Davila, Mahendra and Tagaras, report presented to Prof. Stan Lowy, Dept. of Aerospace Engineering, Texas A&M University (5 May 1988).*

REAR VIEW
OF DUMP TRUCK
(SUSPENSION)

IN TUNNEL ON FLAT LAND

FIGURE 25: DUMP TRUCK SUSPENSION

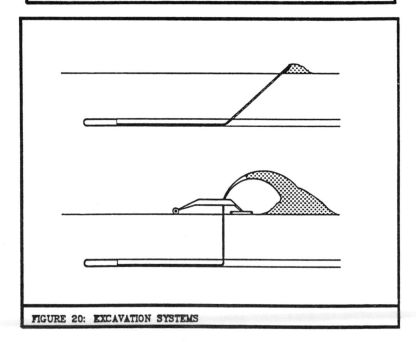

FIGURE 20: EXCAVATION SYSTEMS

ILLUSTRATION 44 - The dumping process from the Lunar Tunneler proposal. In the bottom drawing, excavated lunar soil is sprayed into a large pile by a movable car. *Reprinted with permission from Proposal for a Lunar Tunnel-boring Machine, by Allen, Cooper, Davila, Mahendra and Tagaras, report presented to Prof. Stan Lowy, Dept. of Aerospace Engineering, Texas A&M University (5 May 1988).*

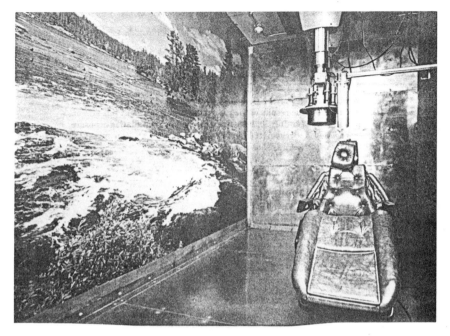

ILLUSTRATION 45 - The Environmental Protection Agency tracks the migration of atomic particles from the Nevada Test Site into the animals and humans of the surrounding environment. This map, modified from an EPA map, shows the location of about 40 families who are brought into the EPA twice a year for whole-body analysis. Part of their examination takes place in the reclining chair pictured in the photograph. The machinery which hangs from the ceiling performs a whole-body scan of the subject. *Source: U.S. Congress, Office of Technology Assessment, The Containment of Underground Nuclear Explosions, OTA-ISC-414 (Washington, DC: US Government Printing Office, October 1989).*

ILLUSTRATION 46 - Samples of raw milk are collected each month from about 25 farms surrounding the Nevada Test Site. *Source: U.S. Congress, Office of Technology Assessment, <u>The Containment of Underground Nuclear Explosions</u>, OTA-ISC-414 (Washington, DC: US Government Printing Office, October 1989).*

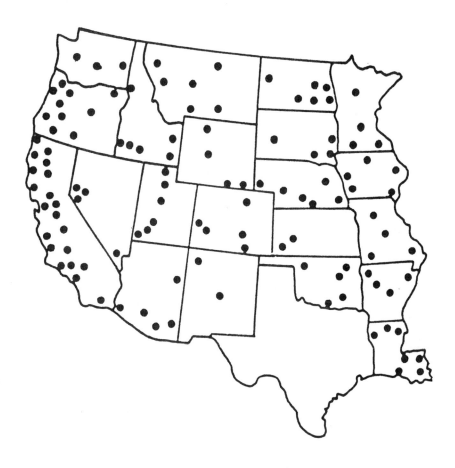

ILLUSTRATION 47 - Is the government more concerned about nuclear pollution of the environment than it lets on? Every year it collects milk samples for analysis from its standby milk surveillance network, which is made up of all of the major milksheds west of the Mississippi River. *Source: U.S. Congress, Office of Technology Assessment, The Containment of Underground Nuclear Explosions, OTA-ISC-414 (Washington, DC: US Government Printing Office, October 1989).*

US005166676A

United States Patent [19]

Milheiser

[11] Patent Number: 5,166,676

[45] Date of Patent: Nov. 24, 1992

[54] **IDENTIFICATION SYSTEM**

[75] Inventor: **Thomas A. Milheiser**, Littleton, Colo.

[73] Assignee: **Destron/IDI, Inc.**, Boulder, Colo.

[21] Appl. No.: **484,458**

[22] Filed: **Feb. 16, 1990**

Related U.S. Application Data

[60] Continuation of Ser. No. 388,761, Aug. 2, 1989, abandoned, which is a continuation of Ser. No. 165,310, Mar. 8, 1988, abandoned, which is a division of Ser. No. 814,492, Dec. 30, 1985, Pat. No. 4,730,188, which is a continuation of Ser. No. 580,401, Feb. 15, 1984, abandoned.

[51] Int. Cl.⁵ ... H04Q 1/00
[52] U.S. Cl. 340/825.540; 340/825.34
[58] Field of Search 340/825.54, 825.55, 340/825.69, 825.72, 825.34, 825.94, 572; 455/118, 41; 375/45, 46, 62, 49; 370/53

[56] **References Cited**

U.S. PATENT DOCUMENTS

3,022,492	2/1962	Kleist et al.	340/825.54 X
3,137,847	6/1964	Kleist	340/825.69 X
3,689,885	9/1972	Kaplan et al.	455/41 X
3,890,581	6/1975	Stuart et al.	375/62 X
3,898,619	8/1975	Carsten et al.	340/572 X
4,114,151	9/1978	Denne et al.	
4,129,855	12/1978	Rodrian	340/825.54
4,287,596	9/1981	Chari	375/49
4,313,033	1/1982	Walker et al.	370/53
4,333,073	6/1982	Beigel	340/825.54
4,368,439	1/1983	Shibuya et al.	375/62 X
4,388,524	6/1983	Walton	340/825.72 X

OTHER PUBLICATIONS

Ray Ryan "Basic Digital Electronics", Tab Books, Blue Ridge Summit, Pa. pp. 52–55, 1975.

Primary Examiner—Ulysses Weldon
Attorney, Agent, or Firm—Earl C. Hancock; Francis A. Sirr

[57] **ABSTRACT**

A passive integrated transponder (PIT) is attached to or embedded in an item to be identified. It is excited via an inductive coupling from an interrogator. The PIT responds to the interrogator via the inductive coupling with a signal constituting a stream of data unique to the identified item. The signal is in the form of two different frequencies, a shift from one frequency to the second during a bit cell representing a data "one", and a shift from the second frequency to the first frequency representing a data "zero". The responsive signal is then detected and processed for utilization in a data storage or display device.

10 Claims, 7 Drawing Sheets

BACKGROUND AND OBJECTS OF THE INVENTION

The primary object of this invention is to provide a system for identifying an object, animal or person consisting essentially of two units, one being a passive integrated transponder (PIT) which is carried by or embedded in the thing or animal to be identified and which responds to interrogation with an identifying code, and the other unit being an interrogator-reader separate from the PIT.

Heretofore, in identification device systems, there is

ILLUSTRATION 48 - This U.S. patent describes the inner electronic workings of an injectable transponder. Note the detail from this patent, which says "The primary object of this invention is to provide a system for identifying an object, animal or person ..." More than one company in the U.S. now sells injectable electronic IDs. They are commonly used to identify livestock or companion animals.

Fact Sheet

United States Air Force
AIR FORCE MATERIEL COMMAND
Office of Public Affairs, Phillips Laboratory
3550 Aberdeen Ave SE, Kirtland AFB, NM 87117-5776
(505) 846-1911

LASER MEDICAL PAC

The Laser Medical Pac, being developed in-house by the USAF's Phillips Laboratory, is a very compact device that provides the field paramedic or physician a unique, portable, and battery-operated laser capability. The laser is able to cut like a scalpel, as well as coagulate bleeding, and close wounds.

The Laser Medical Pac has military applications for advanced trauma life support on the battlefield. It can be used by special operations personnel, pararescue jumpers, squadron medical elements, and flight surgeons. Civilian uses for the Pac are in stabilizing highway accident victims before they are transported to a hospital.

The laser component is now commercially available. The commercial variety, however, requires an electrical power hookup.

The Phillips Laboratory system consists of a completely self-contained laser package that fits inside a beltpack. Laser energy is delivered to the instrument by a fiber-optic cable, the fiber providing very intense power density at the tip of the instrument. The output wavelength, which ranges from visible red to the mid-infrared, can be designed to provide different tissue interactions.

The Pac is powered by two 2-volt batteries to operate the laser and one 9-volt battery to power the electronics. It features a unique phase change heat sink that allows 20 minutes of continuous operation. (Under normal usage the heat capacity should allow unlimited thermal capacity.) The laser is protected against over-temperature by a thermal switch. A battery recharger port is also provided, as is a key lock for safety and security reasons. The fiber-optic is pig-tailed into the laser array and "pipes" the laser light to the variable focus lens. The light at the tip of the fiber is very intense (one kilowatt per square centimeter).

-MORE-

ILLUSTRATION 49 - This medical laser is portable enough to be worn on a belt pack around the waist, and can be used to either make cuts or close wounds. According to the Air Force, "It can be used by special operations personnel ..." *Reprinted with permission from Phillips Laboratory, Office of Public Affairs, Kirtland Air Force Base, NM.*

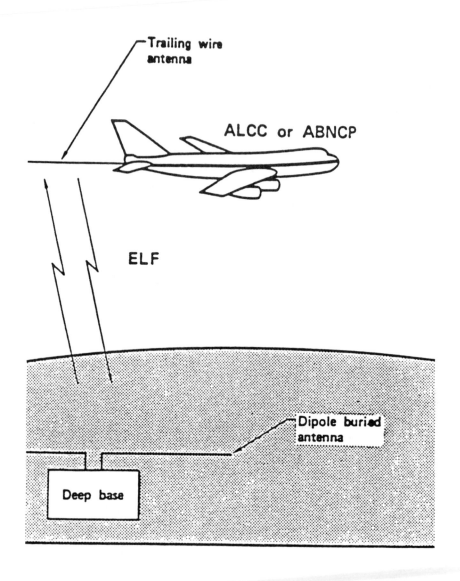

ILLUSTRATION 50 - Communication from a deep underground base could transmit through conventional ground lines; through a satellite or microwave dish; or -- as this illustration shows -- in a way that would be invisible to a surface observer. Extremely Low Frequency (ELF) communications transmit through the earth itself, using a widely-spread underground antenna system. *Source:* *Decision Analysis Methodology Applied to Deep Base Communications*, Subtask Progress Report for 1985 Prepared for the Headquarters, Ballistic Missile Office, USAF. Document ID Nos.: AF MIPR No. FY 7653-85-00305; UCID - 20848; and DE87 000945.

and other flaky characters, and nothing more. In that way, the Pentagon could carry out its underground agenda and prying eyes would be deflected by the threat of public humiliation and ridicule.

In any event, the evidence I have presented above is the closest I can come to documenting an actual, covert, underground tunnel system in the western states. This system may or may not exist.

The Department of Transportation Tunnel Plans

I have found less documentation for the Department of Transportation's planned tunnel system in the Northeast. I was able to find a few documents, however, including one lengthy report that spoke forthrightly about constructing what it referred to as a "High Speed Ground Transportation (HSGT) system in the Northeast Corridor." Presumably the system would be for the use of commuters, although just who would use the tunnels was left somewhat ambiguous. Vague reference to "vehicles" that would use the system also left some doubt as to the mode of transportation that was to have been employed. In the following chapter on unconventional tunneling technologies I present documentation on a flame-jet tunneling system intended for constructing a deeply buried, high speed rail tunnel system in the Northeast. These two sets of documents would appear to be describing plans for one and the same system, the more so since they were both published in the same year (1968).

As set forth in the document, the tunnel system could have ranged as deeply as 3,500 ft. underground. It was to have been at least 500 ft. underground when cutting beneath major rivers, with the exception of the Hudson, under which it was to cross at a depth of not less than 750 ft. Diameters for tunnels in the system were not specified,

though a range of excavated diameters (not to be confused with finished diameters, which would be somewhat less due to the tunnel lining and support) all the way from 8 ft. to 40 ft. was discussed. Specifically, diameters of 8 ft., 20 ft., 30 ft. and 40 ft. were mentioned.

An obvious question is: why would the DOT bother to construct an inter-city tunnel system that would be less than 8 ft. in diameter? It hardly makes sense, except as an auxiliary or utility tunnel for a larger diameter companion tunnel. The larger diameters, of course, could conceivably accomodate some sort of rapid rail, or magnetic levitation train.[16]

Terminals were to range in size between 10,000 and 1,000,000 sq ft. in area, and to have multiple levels. They were slated to be located at least 300 ft., and in some cases, 500 ft. or more underground. They were to have been as much as 2,000 ft. long.

The terminals were to have been situated under or near: Washington, DC; Baltimore, Maryland; Philadelphia, Pennsylvania; New York, New York; New Haven, Connecticut; Hartford, Connecticut; and Boston, Massachusetts. The plans also called for at least one deep shaft between each city to connect with the system. The shafts were to be vertical, and quite large and deep -- extending as far down as 3,500 ft., if necessary, and having a cross-section of between 50 and 500 sq. ft.[17]

Plans vs. Real Tunnels

Once again, the question arises: has this system been built? The planning study is certainly very interesting. In fact, it is just the sort of obscure document you would expect to find if, indeed, a secret tunnel system were being planned and/or built by the U.S. government.

But the reader must be clear on the fact that plans are one thing, and actual tunnels quite another. Sometimes plans culminate in completed construction projects; at other times, plans are never concretely realized and are relegated instead to a dusty shelf in the government documents collection.

I simply do not know if the government (or some other organization) has secretly built a high speed transportation tunnel sytem in the northeastern corridor of the United States. If you do, please send me the relevant documentation.

Chapter Six
TUNNELLING MACHINES
(THE CONVENTIONAL TYPES AND THE SCIENCE FICTION "BLACK" MODELS)

As strange as some of the information that I've presented so far may seem, some of the tunneling machine plans discussed in this chapter are stranger still.

The first thing to understand is that there are actual tunnelling machines that crawl through the ground like giant mechanical earthworms with huge appetites. These tunneling machines are used on construction projects all over the world to build perfectly ordinary sewers, subways, utility lines, highways, railroads, aquaducts, hydroelectric projects -- as well as jazzy, high-profile projects like the "Chunnel", the tunnel underneath the English Channel that now makes it possible to travel on dry ground between England and France.

As for other, more bizarre tunnel systems and tunnel boring machines that are rumored to exist, the best that I can do is to present for your consideration in this chapter new and fascinating information that most readers probably have never seen before. At the least, I think the evidence that is set out in the following pages is intriguing and suggestive.

The discussion begins with the "conventional" machinery -- which you may, nevertheless, find surprising.

Conventional Tunnel Boring Machines (TBMs)

Conventional Tunnel Boring Machines (or TBMs, as they are known in the trade) are huge, cylindrical, mechanical boring machines that tunnel through the rock and soil, chewing out circular tunnels that may range in diameter up to 35 ft. or more (See Illustrations 28 and 29). Conventional rock tunnelling TBMs are powered by electrical motors and have a cutting head, equipped with various metal attachments made of superhard alloys that cut the rock as the head rotates. The head rotates and the cutting tools dig into the rock, ripping and gouging it away. The excavated rock ("muck") is then passed back by a conveyor assembly to the rear of the machine, where it can be hauled away by truck or train.

The tunneling machine braces itself against the walls of the tunnel section it has just bored by means of powerful, hydraulic gripper pads. Other hydraulic jacks thrust the cutter head forward, against the face of the tunnel. When the cutter head is extended as far forward as the thrust jacks permit, the gripper pads are retracted, the machine is advanced forward against the face of the tunnel, the side gripper pads are again extended to lock the body of the machine solidly in place in the tunnel, and the thrust jacks again apply pressure to the cutter head, as it once again begins to grind and tear away at the tunnel face, boring its way through the rock. In brief, that is how a conventional tunnel boring machine works.[1]

The entire assembly, including cutting head, motors, transformers, hydraulic systems, mucking system and conveyors can be up to one hundred feet long or more, as the illustrations show.

The machine may be shielded, to keep rock and debris from falling in on the crew or to prevent tunnel collapse, until a protective tunnel lining can be put in place. Such a

tunnel lining is commonly made of concrete or steel bracing. If the rock is stable enough, however, it may not be necessary to install a lining. Oftentimes rock bolts are used to stabilize the tunnel walls and roof. These are simply long steel rods, threaded on the end, that are screwed or driven into the rock, and which anchor small, flat, steel plates against the wall or roof of the tunnel (See Illustration 14). In this way, the rock bolts lend structural support to weak rock and help prevent rock falls and the like.

Over the last 35 years many of these tunnel-making machines have been produced. They have been used to construct utility conduits, highways, railroads, aquaducts, hydroelectric projects, subways, and more. There is an enormous amount of tunneling activity going on around the world, and most of it is perfectly straightforward, for legitimate purposes. A few of the companies that have manufactured TBMs are: (a) The Robbins Company of Kent, Washington; (b) Jarva Incorporated; (c) The Lawrence Division of the Ingersoll Rand Company; (d) The Hughes Tool Company; (e) Dresser Industries; (f) The Wirth Corporation (a German company); and (g) Atlas Copco.[2]

Many companies have built tunneling machines, but my research shows the Robbins Company to be far and away the leading manufacturer of tunnel boring equipment -- and, in fact, the Robbins Company promotes itself in sales materials as the foremost tunneling firm in the world. Robbins has been in business since the 1950s and has made many of the conventional TBMs in use. In 1993, The Robbins Company merged with Atlas Copco Mechanical Rock Excavation; the new business is known as "The Robbins Company: A company in the Atlas Copco Group". Promotional literature from the new Robbins Company

says, "The next TBM we build for you, whether Robbins or Jarva, will be the best you have ever bought." All of the TBMs in Illustrations 28 and 29 were built by Robbins. That is not to say that other companies are not involved with tunneling projects, because they are.

For projects requiring a huge shaft bored straight down into the earth (and some of the projects described in this book call for vertical shafts), the Robbins Company manufactures the appropriate machinery (See Illustration 30).

In the Arnold Schwarzennegger movie, *Total Recall,* about a futuristic, CIA-operated mining colony on Mars, tunneling and mining machines were depicted that somewhat resemble machines that are already in actual use right here on Earth. These machines are called roadheaders, and mobile miners.[3] See Illustrations 31-33 for a Robbins mobile miner, and the kind of tunnels that it is capable of excavating. Robbins prides itself on the rapidity with which these types of machines operate. The brochure from which these illustrations are taken boasts: "The high advance rates of tunnel boring machines are well documented. ... the Mobile Miner can provide continuous, rapid advance of headings, and can create ideal cross-sections for the safe and rapid transportation of men and equipment underground. The flexibility and maneuverability of the Mobile Miner provide high speed tunneling ..."

Consider the size of the field in which the mobile miner is depicted as operating in Illustration 32: each of the square grids is 1,000 feet wide; the whole area is over a mile wide. Look at the beautiful dowward-spiralling tunnel in Illustration 33; the width of the tunnel is about 15 feet. That's wide enough for two average-size cars to pass one another.

This is what industry is capable of doing right now, and it is impressive.

Drill and Blast Method

Before moving on to discuss nonconventional tunnel boring technologies I want to mention one other conventional method of tunneling, the drill and blast method. It has been used for a couple of centuries or more (mostly in hard rock mining) and its very name describes the method well.

Holes are drilled in the tunnel face; explosives are placed in the holes; the explosives are detonated; the rock disintegrates under the force of the explosion; and the disintegrated rock (muck) is removed by front end loaders to trucks, or other conveyors, such as narrow gauge trains, which cart away the debris. This cycle is repeated over and over again to lengthen the tunnel until the job is completed. There is nothing magical about this process. Any miner will tell you that it simply entails a lot of difficult, dangerous work.

No doubt much of the underground construction for the facilities mentioned in this report has been accomplished using the drill and blast method. While not glamorous, underground drilling and blasting is a time-proven, sure-fire way to excavate underground tunnels and chambers. It is a known technology and it works. All of the myriad mining companies in the United States and around the world use this technique every day to mine everything from coal, to copper, iron, salt, uranium, tin, gold, silver and lead.

In other words, there is a huge pool of workers in the United States alone who have experience in the mining industry and who have tunneled or excavated underground using drill and blast techniques. This author, for instance,

was once employed by Morton Salt and actually worked for a brief period on the powder crew in a salt mine 800 ft. underground, drilling and blasting out huge caverns in the rock salt.

I can assure you that there is a ready supply of experienced labor that could easily be tapped for covert mining, tunneling and excavation projects -- especially the kinds that pay good government wages!

Nonconventional Tunneling Machines

Like many students of UFOlogy (and perhaps like some of the readers of this book) I have heard rumors in recent years of mythical TBMs that use lasers to bore their way through the rock.

As the stories run, these wondrous machines slice through the subterranean depths like a hot knife through butter, leaving neat, glass-walled tunnels in their wake. Although I have never seen one of these machines, or the glass-walled tunnels they allegedly make, I do not dismiss these stories out of hand.

As you are about to see, it is entirely conceivable that laser powered Tunnel Boring Machines, or equally exotic machines, have been developed and have been put to work on secret tunneling projects. I don't positively know that to be the case, but after reading what follows the serious student will have to admit that it is at least possible that a powerful new generation of nonconventional TBMs may have been developed and deployed -- out of the public eye.

There Must Be 50 Ways To Dig a Tunnel

A 1974 RANN report from Bechtel[4] sets out a whole grocery list of technologies, techniques and apparatuses that could be used for underground tunneling or

excavation. They are all presented as "novel ground disintegration techniques," in an exploratory, research or developmental stage. As you will shortly see, though, at least some of these techniques may be a good deal more advanced than Bechtel was prepared to admit. This was probably as true in 1974, when Bechtel issued the report, as it is today. The techniques Bechtel listed were:

High Pressure Continuous Water Jet
Low Pressure Percussive Water Jet
Mechanically Assisted Continuous Water Jet
High Frequency Electrical Drill
Thermal Mechanical Fragmentation

Conical Borer	R.E.A.M.
Turbine Drill	Explosive Drill
Pellet Drill	Ultrasonic Drill
Spark Drill	Hydraulic Rock Hammer
Electric Arc Drills	Subterrene
Induction Drilling	Water Cannon
Plasma	Electrical Disintegration
Microwaves	Electron Beam Gun
Jet Piercing Flame	Forced Flame
Terra-Jetter	Lasers

Some of this stuff is straight out of Buck Rogers. There's no getting around the fact that the plain English translation of some of these entries is: *ray gun*. It does seem a bit far-fetched, but suppose there are actually machines that use these technologies tunneling away beneath our feet!

No matter whether it's science fiction fantasy or high-tech reality, this information comes straight out of an official government document. Here is a case where truth may yet prove to be as strange as any fiction!

The Already Strange Gets Even Stranger

Lest you think the 1974 Bechtel report to be beyond the pale, consider a 1971 article on tunnelling technology that contained the following entries:

- ITT Research Institute has just completed studies of the use of hyper-velocity fluid jets and pellet impact -- design of a high-velocity water cannon is underway and a prototype is planned for testing in 1972.
- United Aircraft Research Labs is studying use of a high-power pulsed laser mounted on a boring machine to weaken rock structures ahead of the cutter blades. If the study is successful, a prototype will be designed this year and then built for field testing in 1972.[5]

Water cannon ... laser ... both of these techniques were mentioned in the 1974 Bechtel report. And this report, from three years earlier, strongly suggests that the techniques were considered more than theoretically interesting. Plans for construction of working prototypes are specifically mentioned. Might these machines actually have been built?

Certainly interest in these exotic mining and excavation methods continued, because an article in the 1982 edition of an industry handbook[6] listed many of the same technologies again:

MECHANICAL: Water Cannon, Vibration, Abrasion, Cavitation, Pellet Impact

THERMAL: High-Velocity Flame, Flame Jet Cutting, Electric Arc, Electron Beam, Plasma, Freezing, Laser, Atomic Fusion

CHEMICAL: Softeners, Dissolvers

Again, most of these techniques are mentioned in the 1974 Bechtel report cited above. The techniques mentioned in the 1971 article discussed above also appear in this 1982 article.

The author of the 1982 article singles out the water cannon and flame jets as showing particular promise for tunneling machines. The water cannon essentially grinds away the rock face by directing a high-pressure, pulsed, water jet against it. Calweld and Exotech, Inc. are two companies mentioned in connection with development of water jet-assisted tunneling.

Flame jet tunneling uses very high temperature jets of flame to cut through the rock. United Aircraft Laboratories, cited above in connection with a partially laser powered tunneling machine, has done developmental work on flame jet tunneling.

Flame-Jet Tunneling

In a three-volume 1968 report, United Aircraft Research Laboratories presented a study of the feasibility of flame-jet tunneling. The report seems to have been stimulated by the professed desire of the U.S. Department of Transportation to find a more efficient means of tunneling so that it could construct a high speed, underground rail corridor in the northeastern part of the country. This appears to refer to the same, deep underground tunnel system discussed earlier in this report, which was to have connected the northeastern urban corridor between Washington, DC and Boston, Massachusetts. To my knowledge, an underground project fitting that description has never been carried out.

The flame-jet tunneler, as described by United Aircraft Research Laboratories, travels on crawler treads. High temperature jets of flame are directed against the tunnel

face, and as the cutting head rotates the flame-jets cut into the rock. Other attachments on the cutting head break off the rock and dump it onto a muck conveyor to be carried to the back of the machine (See Illustrations 34 and 35). There the muck is transferred to the cars of a muck train to be carried to the rear of the tunnel, and hoisted to the service for disposal.

Due to the combustion gases and high temperatures generated by the flames the tunneling crew would ride behind the tunneler in a climate controlled cab (See Illustration 36). When they ventured outside, into the tunnel environment, they would wear suits like those that astronauts wear, to protect them from the heat and poisonous gases in the tunnel (See Illustration 37). The actual size of the tunnel could be as much as 30 ft. in diameter. Power would be drawn from a high-voltage electrical supply.

Flame-jet tunneling would leave a smooth wall, as the flame seared and broke the rock. *Vol. I* of the report estimates the cost of flame-jet tunneling for a 20 ft. diameter tunnel, at anywhere from 44% to 28% of the cost of the drill and blast method. The authors of the report state that flame-jet tunneling is especially suited for very hard rock tunneling, where mechanical TBMs have a much slower rate of progress.[7]

The second volume of the report runs to more than 350 highly detailed pages of cost and efficiency analysis, engineering studies, and various other plans for using flame-jet tunnel machines to construct a tunnel system 1,000 ft. underground.[8] The third volume discusses dated, conventional tunneling techniques.

As with so much else in this report, the flame-jet tunneling *documents* are real. But have actual flame-jet tunneling *machines* been built? And are there really flame-

jet tunneling crews in "moon suits" 1,000 ft. underground, boring through the bedrock, making secret tunnels for who-knows-what reason?

Pulsed Electron Tunnel Excavator

This exotic piece of equipment turned up in a single article.[9] Like the other nonconventional tunneling machines, it is presented as an interesting, but untried technology. The article speaks of a Pulsed Electron Tunnel Excavator that would in theory be "capable of tunneling approximately ten times faster than conventional drill/blast methods." It would do this by wearing away the rock face with a very high voltage beam of electrons, something like an electronic sand blaster. Most of the resulting muck would be small particles of sand and dust that would flake off and be removed from the tunnel face by a slurry pipeline. Larger chunks of rock would be removed by a conveyor (See Illustration 38).

Has this machine really been built, or is it just another Buck Rogers scheme that never got past the conceptual design stage? I don't know -- but if *you* do, contact me with the relevant details.

Nuclear Subterrenes

The nuclear subterrene (rhymes with submarine) was designed at Los Alamos National Laboratory, in New Mexico. A number of patents were filed by scientists at Los Alamos, a few federal technical documents were written -- and then the whole thing just sort of faded away.

Or did it?

Nuclear subterrenes work by melting their way through the rock and soil, actually vitrifying it as they go, and leaving a neat, solidly glass-lined tunnel behind them.

The heat is supplied by a compact nuclear reactor that circulates liquid lithium from the reactor core to the tunnel face, where it melts the rock. In the process of melting the rock the lithium loses some of its heat. It is then circulated back along the exterior of the tunneling machine to help cool the vitrified rock as the tunneling machine forces its way forward. The cooled lithium then circulates back to the reactor where the whole cycle starts over. In this way the nuclear subterrene slices through the rock like a nuclear powered, 2,000 degree Fahrenheit earthworm, boring its way deep underground.

The United States Atomic Energy Commission and the United States Energy Research and Development Administration took out patents in the 1970s for nuclear subterrenes. The first patent, in 1972 (See Illustration 39) went to the U.S. Atomic Energy Commisssion.

The nuclear subterrene has an advantage over mechanical TBMs in that it produces no muck that must be disposed of by conveyors, trains, trucks, etc. This greatly simplifies tunneling. If nuclear subterrenes actually exist (and I do not know if they do) their presence, and the tunnels they make, could be very hard to detect, for the simple reason that there would not be the tell-tale muck piles or tailings dumps that are associated with conventional tunneling activities.

The 1972 patent makes this clear. It states:

...(D)ebris may be disposed of as melted rock both as a lining for the hole and as a dispersal in cracks produced in the surrounding rock (italics mine). The rock-melting drill is of a shape and is propelled under sufficient pressure to produce and extend cracks in solid rock radially around the bore by means of hydrostatic pressure developed in the molten rock ahead of the advancing rock drill penetrator. All melt not

used in glass-lining the bore is forced into the cracks where it freezes and remains ...

... Such a (vitreous) lining eliminates, in most cases, the expensive and cumbersome problem of debris elimination and at the same time achieves the advantage of a casing type of bore hole liner.[10]

There you have it: a tunneling machine that creates no muck, and leaves a smooth, vitreous (glassy) tunnel lining behind.

Another patent three years later (See Illustrations 40 and 41) was for:

A tunneling machine for producing large tunnels in soft rock or wet, clayey, unconsolidated or bouldery earth by simultaneously detaching the tunnel core by thermal melting a boundary kerf into the tunnel face and forming a supporting excavation wall liner by deflecting the molten materials against the excavation walls to provide, when solidified, a continuous wall supporting liner, and detaching the tunnel face circumscribed by the kerf with powered mechanical earth detachment means and in which the heat required for melting the kerf and liner material is provided by a compact nuclear reactor.[11]

This 1975 patent further specifies that the machine is intended to excavate tunnels up to 12 meters in diameter or more. This means tunnels of 40 ft. or more in diameter. The kerf is the outside boundary of the tunnel wall that a boring machine gouges out as it bores through the ground or rock. So, in ordinary English, this machine will melt a circular boundary into the tunnel face. The melted rock will be forced to the outside of the tunnel by the tunnel machine, where it will form a hard, glassy tunnel lining

(see the appropriate detail in the patent itself, as shown in Illustration 41). At the same time, mechanical tunnel boring equipment will grind up the rock and soil detached by the melted kerf and pass it to the rear of the machine for disposal by conveyor, slurry pipeline, etc. (See Illustrations.)

And yet a third patent was issued to the United States Energy Research and Development Administration just 21 days later, on 27 May 1975 for a machine remarkably similar to the machine patented on 6 May 1975. The abstract describes:

> A tunneling machine for producing large tunnels in rock by progressive detachment of the tunnel core by thermal melting a boundary kerf into the tunnel face and simul- taneously forming an initial tunnel wall support by deflec- ting the molten materials against the tunnel walls to pro- vide, when solidified, a continuous liner; and fragmenting the tunnel core circumscribed by the kerf by thermal stress fracturing and in which the heat required for such opera- tions is supplied by a compact nuclear reactor.[12]

This machine also would be capable of making a glass- lined tunnel of 40 ft. in diameter or more.

Perhaps some of my readers have heard the same rumors that I have heard swirling in the UFO literature and on the UFO grapevine: stories of deep, secret, glass-walled tunnels excavated by laser powered tunneling machines. I do not know if these stories are true. If they are, however, it may be that the glass-walled tunnels are made by the nuclear subterrenes described in these patents. The careful reader will note that all of these patents were obtained by agencies of the United States government. Furthermore, all but one of the inventors are from Los Alamos, New Mexico.

Of course, Los Alamos National Lab is itself the subject of considerable rumors about underground tunnels and chambers, Little Greys or "EBEs", and various other covert goings-on.

A 1973 Los Alamos study entitled *Systems and Cost Analysis for a Nuclear Subterrene Tunneling Machine: A Preliminary Study,* concluded that nuclear subterrene tunneling machines (NSTMs) would be very cost effective, compared to conventional TBMs. It stated:

> Tunneling costs for NSTMs are very close to those for TBMs, if operating conditions for TBMs are favorable. However, for variable formations and unfavorable conditions such as soft, wet, bouldery ground or very hard rock, the NSTMs are far more effective. Estimates of cost and percentage use of NSTMs to satisfy U.S. transportation tunnel demands indicate a potential cost savings of 850 million dollars (1969 dollars) through 1990. An estimated NSTM prototype demonstration program cost of $100 million over an eight-year period results in a favorable benefit-to-cost ratio of 8.5.[13]

Turn to Illustration 42, which is reproduced from a second 1973 Los Alamos study, this one entitled *Large Subterrene Rock-Melting Tunnel Excavation Systems: A Preliminary Study* and compare it to Illustration 41, from the patent issued in 1975. Without belaboring the point, I would like to call attention to the almost exact duplication of shared elements in these two drawings. Was the 1973 feasibility study only idle speculation, and is the astonishingly similar patent two years later only a wild coincidence? As many a frustrated inventor will tell you, the U.S. Patent Office only issues the paperwork when it's satisfied that the thing in question actually works!

In 1975 the National Science Foundation commissioned another cost analysis of the nuclear subterrene. The A.A. Mathews Construction and Engineering Company of Rockville, Maryland produced a comprehensive report with two, separate, lengthy appendices, one 235 and the other 328 pages.

A.A. Mathews calculated costs for constructing three different sized tunnels in the Southern California area in 1974. The three tunnel diameters were: a) 3.05 meters (10 ft.); b) 4.73 meters (15.5 ft.); and c) 6.25 meters (20.5 ft.). Comparing the cost of using NSTMs to the cost of mechanical TBMs, A.A. Mathews determined:

> Savings of 12 percent for the 4.73 meter (15.5 ft.) tunnel and 6 percent for the 6.25 meter (20.5 foot) tunnel were found to be possible using the NSTM as compared to current methods. A penalty of 30 percent was found for the 3.05 meter (10 foot) tunnel using the NSTM. The cost advantage for the NSTM results from the combination of (a) a capital rather than labor intensive system, and (b) formation of both initial support and final lining in conjunction with the excavation process.[14]

This report has a number of interesting features. It is noteworthy in the first place that the government commissioned such a lengthy and detailed analysis of the cost of operating nuclear subterrenes. Just as intriguing is the fact that the study found that tunnels in the 15 ft. to 20 ft. diameter range can be more economically excavated by NSTMs than by conventional TBMs.

Finally, the southern California location that was chosen for tunneling cost analysis is thought provoking. This is precisely one of the regions of the West where there is rumored to be a secret tunnel system. Did the A.A.

Mathews study represent part of the planning for an actual, covert tunneling project that was subsequently carried out, when it was determined that it was more cost effective to use NSTMs than mechanical TBMs?

Whether or not nuclear subterrene tunneling machines have been used, or are being used, for subterranean tunneling is a question I cannot presently answer. If you should happen to know, contact me with the relevant proof.

Nuclear Subselene Tunneling Machines On The Moon?

No discussion of government plans for secret tunneling projects would be complete without considering NASA's plans for tunneling on the Moon.

1980s documents from Los Alamos National Laboratory and from Texas A&M University (under contract to NASA) indicate that there are plans to use "nuclear subselene tunneling machines" to melt tunnels under the Moon's surface, to make living, working, mining and transportation facilities for a lunar colony.

A 1986 Los Alamos report[15] calls for using a fission powered, nuclear subselene to provide the heat to "melt rock and form a self-supporting, glass-lined tunnel suitable for Maglev or other high-speed transport modes." The report recommends burrowing beneath the surface because of the harsh lunar environment. It further mentions that the tunnels would "need to be hundreds, or thousands of kilometers long ..." The actual subselenes would be automatic devices, remotely operated. In 1986, Los Alamos estimated each subselene could be built for about $50 million and transported to the Moon for anywhere from $155 million to $2,323 million. The price tag may seem exorbitantly high, but rest assured that there is easily that

much, and more, available in the military's "black" budget for covert projects. It should be noted that the report did not specify how the nuclear subselenes and their crews would be transported to the Moon.

A 1988 Texas A&M study outlined plans for a slightly different model of lunar tunnel boring machine. The Texas A&M "Lunar Tunneler" would employ a "mechanical head to shear its way through the lunar material while creating a rigid ceramic-like lining" (See Illustration 43). Essentially, this kind of machine would be a hybrid, mechanical TBM that incorporates elements of the nuclear powered subselene. Although the machine would be nuclear powered it would have a mechanical cutter head that would bore through the lunar subsurface. Just behind the cutter head would be a "heating section" that would "melt a layer of lunar material within the excavated tunnel to a depth of only a few inches. This molten material could then be cooled to form a rigid ceramic material suitable for lining the interior of the tunnel."[16]

The Texas A&M designers considered a couple of different muck disposal schemes. The two variants of the first called for the muck to be transferred vertically to the surface and either dumped or "sprayed" into a tailings pile (See Illustration 44). The second concept called for the use of special, tunnel dump trucks that would carry the muck out of the tunnel and dump it on the lunar surface (See Illustration 44). The designers recommend use of an SP-100 fission reactor for power, using liquid lithium heat pipes of the sort developed by Los Alamos National Laboratory for the nuclear subterrene.[17]

A second Texas A&M study, released in May 1988, also recommended use of a lithium cooled nuclear reactor as the power source for a lunar tunneler. In the second tunneler design, there are no mechanical tunneling

components. Instead, the cone-shaped, nuclear powered tunneler melts its way through the subsurface like a subterrene. Some of the melted rock and soil is plastered against the tunnel walls to form a glass-like ceramic tunnel lining. The rest of the melted muck (called regolith) is passed out of the back of the tunneler and then carried to the surface for disposal by the dump trucks that follow the tunneler through the tunnel.[18]

I don't know if there are nuclear tunneling machines secretly making permanent bases and tunnels on the moon. But the NASA plans certainly give cause to wonder.

Chapter Seven
NUCLEAR TESTING, THE EPA, ABDUCTIONS, ANIMAL MUTILATIONS (AND ALIENS?)

If you think the federal government's involvement in secret underground bases is thought-provoking, consider the evidence presented in this chapter of similarities between some aspects of UFO-type "abductions" and the activities of a couple of well-known government agencies.

The tenure of Hazel O'Leary as Secretary of the Department of Energy (DOE) has breathed fresh life into DOE's public relations strategy. O'Leary's commitment to the release of information on nuclear testing in decades past has triggered a slew of unsettling news reports of numerous government-sponsored radiation experiments performed on American citizens in the post-WW II period.

In some cases, it appears the subjects gave their informed consent. In others, it is clear that the subjects had no idea that they were being exposed to radioactive substances, or to radioactive fallout. For example, in one case, people were given plutonium injections without their knowledge or consent. In another case, citizens of northern New Mexico were exposed to radioactive clouds that wafted over the region subsequent to the vaporization of radioactive elements at Los Alamos National Labs by conventional explosives.

New information continues to be made public about the extent to which widely divergent sectors of the public have been exposed to the radioactive poisons released by the military, the former Atomic Energy Commission and its successor, the Department of Energy. Given what has been

revealed so far, the scope of the public's exposure to potentially harmful radiation sources could be far greater than the federal government has led us to believe.

In fact, the existence of a little-known human surveillance and monitoring program run by the Environmental Protection Agency (EPA) suggests that it may well be. Interestingly, in conjunction with the human surveillance and monitoring program the EPA also conducts a milk sampling and animal monitoring program. All of these programs are designed to detect the presence of abnormal levels of radioactive isotopes in the body tissues of the human and animal subjects they monitor.

What does any of this have to do with the so-called "abductions" and "animal mutilations" that have been prevalent in the UFO literature in recent years? As it turns out, there is an uncomfortably close parallel or similarity between the EPA's activities and some of the strange goings-on that many UFOlogists have attributed to supposed aliens, such as the infamous "Little Greys".

To begin with, there is a coincidence in time. The government testing program is run by the EPA, which was established in 1970. As it happens, the human abduction and animal mutilation reports began to occur in large numbers over the last 20 years. During that period there has been a virtual deluge of reports in the UFO literature concerning purported abductions of unwilling humans by aliens. In many cases, those who have alleged themselves to have been abducted report that they were subjected to a variety of procedures that resemble, however darkly, some sort of medical examination. There are many reports of sperm and ova samples being taken. Various cuts, scars and scoop marks are said to be the result of alien probing of human bodies. And in many cases, people report being laid on some sort of examining table and having their bodies scanned with some sort of high-tech instrument that is used to examine them from head to toe, in somewhat the same manner that Magnetic Resonance Imagers (MRIs) are

used today.

And there have been many reports of mutilations of animals. As with human abductions, these mutilations are also alleged to be the work of intrusive aliens. For the most part, the alleged mutilations have occurred with farm animals such as cattle and horses. Various body parts are reportedly taken, such as cow udders, anuses, sex organs, tongues, lips and the occasional internal organ. In addition, these mutilations are frequently said to involve the draining of the animal's blood.

First reported in large numbers in the 1970s, mysterious animal mutilations are alleged to continue to the present day, with cases reported recently in Colorado, New Mexico and Alabama.

In broad outline, these are the facts as alleged by numerous personalities in the UFO field. I do not claim to be an expert in these matters or to know whether or not alien abduction and examination of humans and alien mutilation of animals are, or are not, occurring. I am willing to give a hearing to those who maintain that they are occurring. But I am not able personally either to rigorously prove or disprove the sensational claims that many have made in recent years. I have taken the attitude of a juror in a complex, confusing legal proceeding. I am biding my time, waiting for more and better evidence before deciding one way or the other with respect to these matters.

A real U.S. government surveillance program

Having said that, there is solid documentation for an ongoing, years-long U.S. government program of human surveillance, involving medical examinations and scanning of the entire body. There is equally strong documentation for an ongoing, years-long program in which animals, including horses and cattle, are killed and body parts and tissues, including the blood, are collected and analyzed. This program, detailed in a 1989 government report, is

carried out by the EPA. It is the official United States government offsite monitoring project for detection of radioactive contamination from nuclear testing at the Department of Energy's Nevada Test Site.

As part of the program, 31 air monitoring stations are set up throughout the southern two-thirds of the state of Nevada, in western Utah, and in California near the border with Nevada. Air samples are collected three times a week. Air samples are also collected every three months and analyzed for radiation at 86 other air monitoring stations scattered throughout the states west of the Mississippi. Some 130 other locations throughout Nevada, Utah, northwestern Arizona and parts of California near the Nevada border are monitored with thermolumiscent dosimeters designed to record levels of absorbed radiation. These stations are checked every three months as well. Additionally, the water in 51 wells both on and off the test site is checked monthly for radioactive contamination.

Most interesting for UFOlogists, there is an ongoing human surveillance program in which about 40 families are closely monitored. These people live near the test site and are brought in by the Environmental Protection Agency twice a year to be scanned by a "whole body counter" (See Illustration 45). Notice the small room and padded, reclining chair on which persons being examined lie. Notice, too, the whole body counter which telescopes down from the ceiling to examine the subject. Oddly enough, the small room, the reclining chair and the examination instrument are very strongly reminiscent of the small chambers, examining tables and body scanners alleged to be used during purported alien abductions. The fact that families are examined is also interesting, in that the (supposed) alien abduction scenario also seems to sometimes involve abduction and examination of more than one individual in a family.

A variety of animals are also periodically examined. These include cattle purchased from herds near the test

site, as well as bighorn sheep, mule deer, chukar and horses that are shot by hunters or killed in accidents. The tissues and organs are then analyzed for radioactivity. These include muscle, lung, liver, kidney, bone and blood (yes, blood is a tissue). Here again, there is a clear parallel strongly reminiscent of alleged animal mutilations by aliens, involving some of the same species, as well as some of the same tissues.

Finally, there is a milk sampling program. Every month the EPA analyzes raw milk from about 25 farms in Nevada and adjacent areas of Utah and California (See Illustration 46). Raw milk from 120 other farms in states west of the Mississippi is analyzed on an annual basis (See Illustration 47). This is done because grazing cows ingest radioactive particles that may be deposited on their pastures by air or rain. These particles then pass through their udders and into their milk. So analyzing cows' milk is a convenient way of detecting radioactive contamination of the environment.

Here again, there may be a parallel with alleged alien animal mutilations, although in this case the connection (if it exists) may be more indirect. In many so-called cattle mutilations, the udder of the victimized animal is conspicuously cut out and removed. Of course, the udder contains the milk producing glands of the cow. Consequently, anything present in a cow's milk would logically pass through and/or be present in its udder as well.

Presumably, then, analyzing udder tissues would reveal many of the same radioactive substances, if present, that an analysis of milk produced by those same udders would reveal. As it happens, milking a cow takes time. This might present a problem for busy aliens operating under rigid time constraints (assuming aliens are responsible for the mutilations). Might it be conceivable that under the circumstances it is simpler for "them" just to cut and run?

Who is behind the mutilations and "abductions"?

Whatever the truth of the matter, it is curious that the U.S. government has a testing program that monitors both animals and humans in ways that so strongly mimic the pattern of activity characteristic of alleged alien abduction of humans and alleged alien mutilation of animals, particularly cattle. Is there a connection between the official, albeit little known, government program and the numerous abduction and mutilation stories that have swirled through the UFO world? If so, what is the nature of the link? Are the alleged alien abductions and mutilations really part of a much wider, more pervasive program of covert monitoring of humans and animals by the government? Are alleged aliens and UFOs a convenient cover story that secret government agencies use to hide their tracks? Are the alleged abductors and mutilators really terrestrial humans, working undercover for the U.S. government or some other, non-governmental, covert agency? And if they are, what is the purpose of such an extensive monitoring program? One shudders to think. From the standpoint of violated civil liberties alone the implications would be sobering. And it may mean that the nuclear genie has let loose something unspeakably horrendous from its atomic bottle, the awful nature of which has yet to be divulged to us.

Or are real, live aliens to blame for the reported abductions and mutilations? Is it mere coincidence that their activities so closely resemble those of the U.S. government? Or are they running a testing program that is basically looking for the same things as the EPA? Do they share the same concerns? Are they operating independently of one another? Or are aliens and covert elements of the U.S. government perhaps working together? And if so, for what reason? Of course, this line of speculation assumes that there are aliens in the first place, and that if there are, that they are involved in abducting and examining humans and also in killing and mutilating

animals.

Whatever the case may be, we are left with the reality of the reports of "alien abductions", as well as carcasses of animals allegedly killed and mutilated by aliens. The precise reality behind the reports of abductions and the precise circumstances surrounding the deaths and mutilations of the animals are not known for certain. We must remember that not much is known about these incidents.

Debunkers have chalked up the dead animals and mutilations to normal disease, accidents and predator activity. Likewise, they decry the tales of abductees as dreams, flights of fancy and fevered imaginings. And maybe the debunkers are right.

On the other hand, the mounting weight of anecdotal evidence from numerous witnesses who attribute these incidents to alien activity cannot easily be ignored. It does seem possible that something highly strange, perhaps involving another sort of intelligent, and certainly very exotic, species is going on. But in the final analysis, it is virtually impossible to say for sure.

What can be said for certain is that in recent years the U.S. government has had an extensive human and animal surveillance and monitoring program which in several essential aspects closely resembles activities often attributed to supposedly alien beings.

Curious to know more about possible EPA activities in this regard, in late January 1994 I called the agency's office in Las Vegas, Nevada to find out the official government line on animal monitoring and human surveillance. After being passed around in the bureaucracy for a couple of hours I eventually received a call from a noticeably wary spokeswoman who doled out information to me by dribs and drabs. She sighed; she hemmed and hawed; she pled ignorance; she referred me to another office; she equivocated; she spoke indistinctly; she paused and hesitated in her answers.

But at my persistent urging she did admit the following: human surveillance around the Nevada Test Site began around 1957, and today includes about 100 people, many of them from local ranching families, both parents and children. These people are brought in to the Environmental Systems Monitoring Laboratory at the University of Nevada-Las Vegas, where their bodies are scanned for radioactive isotopes by a "whole-body counter". She said that some of these people have been continuously tracked since the late 1960s. The spokeswoman said she did not know if similar programs of human surveillance are conducted near the nation's other nuclear laboratories and test facilities, such as Savannah River, South Carolina; Hanford, Washington; Pantex, Texas; Sandia and Los Alamos, New Mexico; and Oak Ridge, Tennessee.

Where animals are concerned, sampling began in Nevada before 1960. I was told the program consists of a man who is sent out in a truck and told the number and kind of animals to slaughter for testing. The spokeswoman said that there is no animal monitoring outside of Nevada. However, in response to my prodding she did say that Lovelace Medical Center, in Albuquerque, New Mexico, may have done some animal monitoring as a follow-up to dispersion of radioactive isotopes from nuclear testing at Los Alamos National Laboratories, in northern New Mexico. But she was not certain of this, and mentioned it only as a possibility.

But whether true or not, it is an intriguing thought. Lovelace has had a long relationship with the military-industrial complex that continues to the present day. And Lovelace currently operates a large, sophisticated, animal research facility on the grounds of the Sandia National Laboratories/Kirtland Air Force Base complex on the outskirts of Albuquerque (as well as medical facilities for humans, also in the Albuquerque area). Of course, this in no way proves that Lovelace is involved in animal mutilations (or human abductions). On the other hand,

Albuquerque is awfully close to the areas of northern New Mexico and southern Colorado where so many cattle mutilations have been reported. And if the mutilations and abductions are being done by covert human operators, since the medical expertise at Lovelace and the helicopters and other equipment from Kirtland AFB and Sandia National Laboratories are as state-of-the-art as can be found anywhere, one could speculate there might be a connection.

On a final note, since unmarked, dark helicopters are sometimes reported in the vicinity of animal mutilations, I asked the EPA spokeswoman whether the EPA ever used helicopters to carry out its animal testing program. She denied that the EPA operates in this way.

And that was the end of the interview. As I hung up the phone I was struck by the spokeswoman's reticence to divulge information. I had the distinct feeling she could have told me a great deal more than she did.

In the end, the same question remains: what is going on? We have numerous reports of human abductions, and medical-like testing by seemingly alien beings. There are also many reports of animal mutilations, under strange circumstances, with conspicuous removal of selected body parts. During the same period of time, there is solid evidence from the EPA of an ongoing nuclear contamination monitoring program involving prolonged human surveillance and animal testing that resembles, to a surprising degree, activities often attributed to aliens.

These are the facts as they have been presented by the government and by concerned individuals who allege to have seen and/or experienced animal mutilations and human abductions. To say more than that is to take liberties with the truth. The best I can do is to observe that past this point things become very murky indeed.

Chapter Eight

ABDUCTIONS, NEEDLES AND IMPLANTS:
A FRESH APPROACH

The UFO literature is rife with reports where alleged aliens insert small implants into the bodies of abductees. On occasion the implants are said to be put in place with needle-like devices. Locations of particular choice seem to be behind the ear, and up the nose, in the top of the nasal cavity. The reasons for these abductions, as well as the nature of the implants themselves, remain perfectly obscure. To begin with, it is not clear who is perpetrating the abductions; and neither is it clear what function(s) the implants perform.

But given the constantly growing number of people who are reporting these sorts of incidents it seems to me that UFOlogists ought to look more closely at this aspect of the UFO phenomenon. The most simple questions about the abductors and implants beg to be asked: Who? How? Why?

Many abductees, perhaps most, identify their abductors as "aliens". The assumption is often made, and sometimes forthrightly, that these "alien" abductors are extraterrestrial beings. Of course, this assumption may or may not be true. In fact, it may be the case that at least some of the "alien" abductors are actually terrestrial humans working covertly, under cover of artificially induced states of total or partial amnesia, fear and screen memories. There are a wide variety of techniques that can influence, even deeply alter, human perception and emotions. These can be as simple as the use of rubber

masks and make-up (how about a reptilian face mask and body suit?). More sophisticated technologies can cause profoundly realistic hallucinations. Psycho-active drugs, certain microwave radiations, various hypnotic procedures, and flashing lights and rhythmic sounds are some of the ways in which this can be done.

To be sure, there are many, many reports of abductees being asked to drink strange potions and decoctions; smelling strange vapors and gases; seeing flashing lights; gazing deeply into hypnotic eyes; experiencing strange radiations; hearing whirring or humming sounds; and hearing voices in their heads.

I think we have to at least consider the possibility that some of these reported aspects of abductions may actually be earthly technologies used by terrestrial humans to radically alter a subject's perception of reality during an "alien abduction" experience.

There are any number of groups, governmental or private, that have, or could obtain, access to the money, personnel, equipment, materials and expertise to stage a convincing "alien abduction" episode. These organizations include (but are not by any means limited to): the police, intelligence and military agencies of major governments; major corporations and powerful financial institutions operating on a global scale; transnational organizations such as the United Nations, NATO, Tri-Lateral Trade Commission, and Inter-Pol; and other secretive, international organizations such as crime syndicates and fraternal orders.

Consider that some "alien abductees" do, in fact, report seeing other human beings during their abductions, human beings who appear to be involved in, or cooperating with the perpetrators of, the abduction. In some cases these other humans have reportedly been in military uniform. These curious reports certainly suggest the possibility of at least some degree of covert involvement by terrestrial humans in the "alien abduction"

phenomenon.

Of course, just because "alien abductees" allege that "aliens" or "extraterrestrials" used needles or syringe-like devices to insert implants into their bodies, does not necessarily mean that aliens or extraterrestrials of any sort actually did it. It only means that "alien abductees" *say* that is what has happened. The report may be ever so heartfelt -- and many of the accounts are extremely moving and sincere -- but at one and the same time, the report may, or may not, accurately reflect what actually transpired.

Alternate Realities of the Terrestrial Kind

Here are some hard facts: there is now a technology in commercial use that almost precisely mirrors the needle-injected implants said to be inserted into abductees by aliens. There are several companies that now offer miniature, electronic, identification devices for sale, primarily for use in animal-related applications, so that farmers, ranchers and pet owners can keep track of their herds, flocks and pets.[1]

As will be made clear below, these electronic tracking devices are perfectly capable of being injected into humans, as well.

One United States firm, a leader in the field of electronic implants, holds a number of related patents. It manufactures miniature, electronic implants that are injected using a large syringe and needle.

Please note that I am not saying that this U.S. firm, or any other firm making similar products, is in any way involved with the alleged "alien abduction and implantation" phenomenon. But products are being marketed in the United States that are remarkably similar to the implant technology frequently reported in the "alien abductee" literature.

In recent years a series of U.S. Patents have been awarded for an electronic identification system based on

syringe-implantable identification transponders (implants).[2] According to the patents the system involves inserting tiny implants "into animals for their identification, useful in monitoring migratory patterns and for other purposes." The implants are "durable and reliable over a period of years." Moreover, each of the implants are uniquely identifiable.

These "injectable transponders" are about four-tenths of an inch long and less than one-tenth of an inch in diameter.[3] They contain electronic micro-circuits that are activated and read by "a compatible radio-frequency ID reading system." The tiny, "bio-compatible glass" implants contain "an electromagnetic coil, tuning capacitor, and microchip." According to product literature from one of the U.S. makers of these injectable transponders, the chips can be programmed with up to "34 billion unique, unalterable identification codes." The literature says that although the injectable transponders are "specifically designed for injecting in animals, (they) can be used for other applications requiring a micro-sized identification tag."

The transponders are injected with a syringe-like device with a needle on the end. According to the relevant patent the injector needle is "adjustable for implant insertion depth." The patent states that "needles ... of various diameters and lengths may be interchanged in the injector." It specifies that where needle dimensions are concerned "the invention may be adapted to a large range of dimensions." Furthermore, it says the "needle may also be rotated to a plurality of positions relative to the injector handle."[4]

In other words, the device described in this patent could be fitted with a needle that would permit an implant in a variety of locations in the human body, including many, if not all, of the locations reported by people who believe they have been subjected to an "alien abduction and implantation".

Interestingly, three of the patents granted for identi-

fication devices (transponders/implants) explicitly state, in identical language, that the devices are to be "carried by or embedded in the thing or animal to be identified." All three also explicitly state: "the primary object of this invention is to provide a system for identifying an object, animal *or person...*"[5] (my italics) (See Illustration 48).

Furthermore, when the implant is "read" at the appropriate radio frequency the output can be displayed on a computer terminal and transferred to an electronic data storage system.[6]

In plain language, what we have here is the type of technology that, if employed on a large scale, could theoretically electronically monitor, in real time, the whereabouts and movements of as many as 34 billion individual animals *or humans.* Of course, the possibilities and implications for potential political and social control are both obvious and enormous.

I would like to stress again that my research has not shown that any manufacturers or buyers of these injectable transponders are, in any way, either directly or indirectly, involved in either the so-called "alien abduction and implantation" phenomenon, or in monitoring the whereabouts and movements of human beings. I am only using these products as examples of the kind of off-the-shelf implantation and monitoring technology that is being manufactured and marketed today.

What's behind the "abduction" phenomenon?

If social or political control is the motive behind the abductions and implants (and I do not know that it is), then how would such control be carried out? One possible answer is: genetically.

Abductees frequently report that their abductors seem preoccupied with human sexuality and breeding. The abductee literature is full of reports of forced breeding; collection of human ova and sperm from unwilling

abductees; stolen fetuses from pregnant abductees; and allegations of a human/alien crossbreeding or hybridization project.

To be sure, the accounts of "alien abuctions", taken all together, make for a bizarre collection of literature. But suppose the stories contain an element of truth -- at least in broad outline?

Let us assume, hypothetically, that there is some kind of covert human breeding program going on, for reasons known only to the abductors (whoever they might be). Those reasons need not necessarily be those given by the abductors, or inferred by the abductees.[7] For the sake of example, suppose the abductors for whatever reason want to mate a 40 year old woman in Des Moines with a 22 year old man in Bombay; or a 34 year old woman in London with a 65 year old man in Tokyo? Of course, these are people living in different countries, speaking different languages, immersed in different cultures and religions. The chances that they would pair up and mate if left to their own devices are minuscule.[8]

Enter our mystery abductors, to do their covert, "alien" match-making. Abductees might be physically mated (as is sometimes reported in the literature). Or, where this is not feasible, sperm and ova samples collected from unwilling donors could be stored, then mixed and matched later for the desired genetic combination. Fertilized eggs could be implanted; fetuses could be removed. In vitro fertilization and artificial wombs could be used to produce fetuses and bring them to term.[9]

Clearly, if any known organization openly went around in this way, forcing people to mate with one another against their will, the hue and cry would be enormous. Society would be in an uproar. So any large scale, forced-breeding program would have to be very secret to be successful. And the perpetrators would certainly have to carefully conceal both their identities and motives in order to avoid being caught out by their victims

and the public at large. Obviously, they would have to be very stealthy in picking up and monitoring their "breeders."

The fact that human reproductive capacities change also complicates matters. People reach puberty; they get pregnant; they reach menopause; they have their tubes tied; they have vasectomies; their ova/sperm become fertile/infertile. How to tell whether the person(s) of interest can produce viable offspring? And how, finally, to find the desired persons on any given day, at any given hour?

Enter the electronic monitoring and identification implant. Product literature from at least one U.S. manufacturer discusses how an animal breeder (farmer) can use their product to identify and monitor the breeding status of hogs and cows. The question naturally arises as to whether the same (or very similar) technology is being used by others who regard abductees as part of their "herd."[10] Are abductees perhaps implanted for the same reasons that a hog farmer monitors his pigs -- to keep track of their breeding status?

It is an interesting line of speculation which may or may not be related to the "implant" aspect of the abduction phenomenon of recent years. And it may or may not have anything to do with purported "alien" activities on this planet. But I think the reader will agree that the very real implant technology discussed earlier in this chapter bears more than a little resemblance to the implant technology often attributed to alleged "alien" abductors.

Might we be dealing with a covert implantation/ monitoring program that is being carried out very stealthily and furtively by very real human agencies and operatives? Might they have a devious motive of political and social -- or even physical -- control? Are they carrying out a massive, secret, forced-breeding program? Might they use the UFO and "alien" abduction phenomenon as a convenient screen, a sort of otherworldly camouflage to conceal their true identity and purpose?

This whole affair is wonderfully bewildering. On the one hand, there does seem to be a genuine abduction phenomenon, with growing numbers of people who reportedly have been implanted by perpetrators who have so far proven to be impressively elusive and stealthy. They have also proven extraordinarily adept at passing themselves off as "aliens" or "extraterrestrials".

On the other hand there is now a commercially available, human manufactured, terrestrial technology that closely resembles the implant technology that has repeatedly been reported to be used by "aliens." It is true that the patents for this technology are of comparatively recent vintage; however the technology itself could well have been developed long before the patents were issued. After all, electronic micro-ciruits have been around for years now. In any event, the fact that the two technologies are so extraordinarily similar raises the question as to whether they might not actually be the same. And if they are the same, then we have to begin looking for a very human, home-grown connection to at least some of the reported abductions.

In the end we find ourselves stuck in a bizarre hall of mirrors full of constantly shifting, bizarre images, each one more improbable than the next. Are the images alien? Human? Are the perpetrators hiding behind disinformation or propaganda masks? Hypnotic masks? Electronically or chemically induced masks?[11]

To be sure, there may be even more troubling permutations of the abduction and implantation phenomena.

For example, entertain the following possibilities: Group "A" (the Army, CIA, NSA, "aliens") abducts and implants human subject "X". Meanwhile, Group "B" (select your favorite from the rogue's gallery above) either strongly suspects or somehow knows that subject "X" has been abducted and/or implanted. However, "B" is not sure how, why or when subject "X" was abducted and

implanted.

But "B" would very much like to know who has abducted and/or implanted "X" -- as well as when and why. So "B" also abducts and implants subject "X." In this way, "B" can keep close electronic tabs on "X" and if "A" again abducts subject "X", "B" will be able to monitor the abduction. "B" may even be able to establish when it occurs and the location to which "X" is taken.

Group "B" may even be able to monitor the abduction in progress, thereby discovering the identity of Group "A."

Obviously, this game would be a strange one. Kick back and let your imagination run with the possibilities. What if Group "A," for instance, is the U.S. Army and "B" is the U.S. Air Force?

Now, try a variation on the theme. Let "A" be a joint U.S. Army-"alien" alliance, and let "B" be the U.S. Air Force. Liven things up by adding another "alien" group, and another military agency. Suppose that international organizations like the United Nations are also involved, perhaps with interests that are in direct conflict with those of Group "A" or Group "B" -- or perhaps most importantly, with those of human subject "X".

The point I am making is simply that the abduction and implantation phenomena may have interlocking layers of complexity that have not been sufficiently explored or appreciated by most UFO researchers.

Oh, yes. One final thing.

If the possibility of being implanted and electronically tracked and monitored (perhaps without your knowledge or consent) makes you feel a trifle uneasy, just try repeating the following words softly to yourself until you feel more relaxed: "New World Order ... New World Order ... New World Order ..."

Chapter Nine

IS THE U.S. MILITARY INVOLVED IN "ALIEN" CATTLE MUTILATIONS?

For years investigators of the cattle mutilation phenomenon have reported that wounds and cuts on many of the mutilated carcasses seem to have been made by some sort of surgical laser device. The unnatural precision and cleanliness of incisions, as well as evidence of unnatural heating of the tissues near the wounds have all pointed to probable use of surgical laser scalpels in many cattle mutilations.

Though there is little doubt that the mutilations are occurring, it has not been clear who the mutilators are. There have been many allegations that the mutilators are "aliens" or extraterrestrials -- but no hard proof.

For many years, the working assumption has been that human involvement in the mutilations was not possible because there is presumed to be no known "earthly" technology that could carry out these mysterious mutilations. Reasons given include such factors as the surgically precise, "laser-like" incisions and wounds (allegedly impossible with contemporary medical technology); lack of footprints; and absence of blood around mutilated carcasses.

But the presence of mysterious, unidentified helicopters in the vicinity of many cattle mutilations has long been noted. The fact that helicopters are a 20th century, terrestrial technology has led to speculation that

the "alien" hypothesis for the cattle mutilations may not satisfactorily explain every facet of the phenomenon.

In fact, there may be very real, covert human involvement in the cattle mutilations. To begin with, it is simply not true that modern medical technology cannot and has not produced a portable, surgical laser that can be taken into the field (literally!).

The Phillips Laboratory at Kirtland Air Force Base, in Albuquerque, New Mexico recently announced that it has developed a "very compact device" called the "Laser Medical Pac" that provides the "field paramedic or physician a unique, portable, and battery-operated laser capability." The portable laser is a "completely self-contained laser package that fits inside a beltpack." (See Illustration 49). It requires "two 2-volt batteries to operate the laser and one 9-volt battery to power the electronics." It measures 7" by 3" by 2.5". It can operate continuously for 20 minutes at a time. The tip of the instrument is a "variable focus lens" at the tip of a flexible, fiber-optic cable that "provides very intense power density."

The device is "able to cut like a scalpel, as well as coagulate bleeding, and close wounds." It may be used by "special operations personnel" and others. According to the Office of Public Affairs at Kirtland AFB, "The output wavelength, which ranges from visible red to the mid-infrared, *can be designed to provide different tissue interactions* "(my emphasis).[1]

And all of this, mind you, is the size of a transistor radio, and is powered by batteries of the sort you can buy in line at the supermarket. So much for esoteric, "alien" medical technology.

How To Perform a "Typical" Cattle Mutilation

Permit me to present a hypothetical, "earthly" modus operandi for a cattle mutilation.

A dark, unmarked helicopter lifts off from Kirtland Air

Force Base. Inside the helicopter is a "special operations" team outfitted with a tranquilizer dart gun and surgical laser beltpacks. They fly for a couple of hours to an isolated ranch somewhere in a sparsely populated rural area (there are many areas of the rural West where the population density is less than one person per square mile). They land and shoot a cow with the dart gun. The tranquilizer immobilizes the animal so it cannot flee. They capture the animal, kill it and hoist it aboard the helicopter. On board they cut up the animal with the surgical lasers, removing the body parts they want to keep. They may even drain the blood for analysis (see Chapter 7 for a discussion of the types of material that the EPA is interested in for its nuclear contamination tissue sampling program). Then they unobtrusively lower the carcass to the ground from the helicopter, without landing.

Later, the carcass is discovered. There are no footprints or signs of struggle because the cow was picked up at a different place from where its carcass was found; its carcass was subsequently lowered to the ground on a sling, or rolled out the door after being slaughtered, without the helicopter touching down, or the crew leaving the craft.

The wounds on the carcass appear to be made with some type of surgical laser because, in fact, they *were* made with surgical lasers -- surgical lasers carried on the beltpacks of a United States military special operations team. There is no blood around the carcass because the surgical lasers can coagulate bleeding and close wounds. There is no blood inside the carcass because it has been drained out for a tissue sampling project.

Ranchers and others in the area report seeing mysterious helicopters in the vicinity of the cattle mutilation, because the military mutilation teams travel in dark, unmarked helicopters.

So there you have a hypothetical cattle mutilation with all the classic details asociated with an "alien" cattle mutilation -- but plausibly explained as a covert human

operation using technology available now. And it is entirely possible the military has had this portable, surgical laser for years, since the military "black budget" world of special operations routinely conceals its activities from the public as a matter of policy, usually on grounds of "national security".

Why Do a Cattle Mutilation?

Now for the hypothetical "why" of it all.

One possibility is that there is some kind of covert environmental monitoring program going on, one like the Environmental Protection Agency (EPA) program discussed in Chapter 7. Cows are large mammals that are found everywhere that people are found, and they occupy a lower rung on the food chain than most humans, since bovines are herbivores. This means that they would more quickly absorb radioactive or chemical environmental contaminants than would most humans.

Perhaps the problems with our environment are far more serious than we have been told and a massive, covert monitoring program is under way. If this is the case, other government agencies could be involved, such as the EPA and the Department of Energy (See Chapter 7).

But why the emphasis on cattle? Is there some specific reason for singling them out? Must bovine tissues be obtained for some particular purpose, perhaps involving biological or genetic engineering? And if this is the case, what is the nature of the research and why and by whom is it being carried out?

Given the stealthy nature of the mutilations, these are tremendously difficult questions to answer. It may be, after all, that there is some sort of bizarre "alien" or extraterrestrial activity associated with the phenomenon.

But in light of the circumstantial evidence associated with many of the mutilations, such as unmarked helicopters and laser-like, surgical incisions, we would do well

not to turn a totally blind eye to possible culprits closer to home. It is not lost on me, for example, that many of the cattle mutilations have been located in New Mexico and southern Colorado, not far at all by air from Kirtland Air Force Base.

And there are plenty of dark helicopters at Kirtland.

And we now know that laser scientists at Kirtland Air Force Base have developed portable, surgical lasers that can fit in a beltpack.

Coincidence?

I wonder.

Afterword

LAST WORDS ON UNDERGROUND BASES, TUNNELS AND EXOTIC TUNNELING MACHINES

Based on the evidence in this book, it is absolutely certain that there are underground bases that have been secretly constructed in the United States in recent decades.

Who would be most likely to build bases of this kind? Any of the major agencies of the Pentagon would be capable of constructing deep underground facilities. Indeed, I have presented documentation generated by or pertaining to the Departments of the Army, Air Force and Navy and the Defense Nuclear Agency that indicate their interest, or direct involvement, in underground facilities. In my view it is likely that other Pentagon agencies and departments have similar interests, capabilities, and involvement.

Any reader of this book ought to come away with at least this one, basic understanding: the Pentagon is definitely heavily involved in and interested in underground facilities. There is no doubt about that.

A number of other non-military agencies are involved as well. The Department of Energy (DOE), the Federal Emergency Management Agency (FEMA), the National Security Agency (NSA), the Colorado School of Mines, and the Federal Reserve are some of the known underground players.

And there are the Fortune 500 companies that have

underground facilities. AT&T has a number of sophisticated underground centers. Northrop, Lockheed and McDonnell Douglas have hi-tech underground centers in California. Standard Oil at one time had a command post deep underground in New York state. There may be others operated by other companies.

Where secret tunnel systems and exotic tunneling machines are concerned the evidence is less conclusive. There *are* extensive Pentagon plans for a hundreds-of-miles-long tunnel network, thousands of feet underground in the desert Southwest (or somewhere). There are even contracts with the Air Force's Ballistic Missile Office that indirectly indicate that this tunnel system, or perhaps part of it, may have been built. But the evidence is fragmentary and circumstantial, and comes far from definitively proving that there is a secret military tunnel system. I have taken a wait-and-see attitude. The documentation is interesting, but in the final analysis plans, contracts and documents are not the same thing as real tunnels.

So, absent hard proof, the information presented in this book merely demonstrates a very strong military interest in building, even the intent to build, a huge, deep underground tunnel system. Were the tunnels built? Or are they being built right now? The short answer is: I do not know. If you *do* know, send me documentation, and if it's convincing, I'll publish it.

And then there are the plans for the Department of Transportation's deep underground tunnel system in the Northeast, linking major metro areas between Washington, DC and Boston, Massachusetts. Have miners in "moon suits" been operating flame-jet tunnelers to make a tunnel system there, or elsewhere? Planning documents for such a project do exist. But here again, as with the Pentagon plans, documents are one thing, and actual tunnels quite

another.

Of course, for your garden variety secret tunnel system there is a choice of tunneling machines. There is always the dependable, conventional, electrically powered, mechanical TBM. And there are lots of these digging away around the world, making all sorts of tunnels for subways, highways and water works.

Then there are the plans for nuclear subterrenes, electron beam excavators, and flame-jet tunnelers. Do these exotic tunneling machines exist? They might; they might not. But *if* they do you can bet on one thing: they are being used covertly, in considerable secrecy, because I have examined thousands of pages of recent tunneling literature and there is no mention of their use anywhere. At the same time, I did uncover plans for these strange machines generated by the military-industrial complex. So, I do not summarily dismiss the possibility that these machines may be in secret use. There the matter rests for now.

Finally, there are out-of-this-world plans for "subselenean" or lunar tunnelers. In design these machines have many similarities to their earthly, nuclear subterrene or TBM counterparts. If I am at a loss to draw many firm conclusions about secret tunnels and exotic tunneling machines here on Earth, I am at even more of a loss when it comes to deciding about tunneling activity on the Moon.

There are rumors in some of the wilder corners of UFOlogy about a secret space program and covert, manned, lunar bases. Here again: I suppose anything is possible, but I have yet to see any kind of direct proof that this secret space program exists, or that there are secret bases on the Moon. Rumors are not the same thing as solid evidence, and researchers must be careful to remember that simple truth.

So there you have it.

This book constitutes just about as representative a treatment of the subject of underground bases and tunneling activity as is presently possible from reading information that is publicly available in a moderately good research library.

I have no contacts in the intelligence community; I have had no access to classified material. Almost all of the material in this book comes from the public record. Anyone who is willing to do methodical investigation in a good research library and dig hard can find much the same kind of information as that presented here.

Truth to tell, there is certainly interesting information yet to be discovered on all of these topics. To find that information, you have to creatively examine electronic databases, periodical and newspaper indexes, federal document and technical document indexes, patent indexes, card catalogues, and every other kind of index that you can think of. And then you track down the document and article citations that you find.

Serious research is tedious and time consuming. But it can yield results if you stick with it.

A Final Word

Our First Amendment right to freedom of speech and freedom of the press is only as strong as we make it. We have the constitutional right to go into libraries and databases, and to read and then to write about what the government and major corporations are doing. I am exercising this right. I hope that others who read this book will do the same.

I welcome information and plans, diagrams, photos, videos, and all forms of evidence from readers about any

and all underground tunnels, tunneling machines and underground bases -- or strange "UFO" or "extraterrestrial" technology. The more detailed and specific the information is, the more useful it will be. If you desire anonymity, either send me the material anonymously or make your desire for anonymity crystal clear when you communicate with me.

All materials and information become my property, to use or not as I see fit, without further obligation or compensation to the sender.

You may send information directly to me:

Richard Sauder
c/o Adventures Unlimited
Box 74
Kempton, IL 60946 USA

FOOTNOTES

Chapter One -- Oh Yes, They're Real!

1. Lloyd A. Duscha, "Underground Facilities for Defense -- Experience and Lessons," in Tunneling and Undergound Transport: Future Developments in Technology, Economics and Policy, ed. F.P. Davidson (New York: Elsevier Science Publishing Company, Inc., 1987), pp. 109-113.
2. Albert D. Parker, Planning and Estimating Underground Construction, (New York: McGraw Hill Book Company, 1970), pp. 140, 142.
3. U.S. Dept. of Defense, U.S. Army Corps of Engineers, Construction Engineering Research Laboratory, Literature Survey of Underground Construction Methods for Application to Hardened Facilities, Report No. CERL TR M-85/11 (April 1985), pp. 2, 7, 34 and 36.
4. Lt. Col. J.A. Goshorn, "Should We Go Underground," Armed Forces Chemical Journal 3 (July 1949), p. 25.
5. Duncan Campbell, "War Games," New Statesman & Society 2 (26 May 1989), p. 11.
6. "Underground Missile Plant To Be Built Near Redstone," Missiles and Rockets, 2 (May 1957), p. 43.
7. "Underground Factory in the Works?," Missiles and Rockets, 2 (Sep 1957), pp. 52-53.
8. "SAGE Goes Undergound Near Dobbins," Air Force Times, 20 (7 Nov 1959), p. 24.
9. Paul R. Nyquist, PE and Andre M. Ranford, PE, "Diesel Power for Command and Control Centers," Air Force Civil Engineer 5 (February 1964), p. 30.
10. U.S. Department of Defense, Department of the Army, Office of the Chief of Engineers, Utilization of Nuclear Power Plants in Underground Installations, Engineer Manual No. EM 1110-345-950 (15 April 1963), pp. 1-2, 6 and 28-29.
11. Nyquist and Ranford, p. 33.

Chapter Two -- The Military Underground: Air Force, Army and Navy

1. J.J. O'Sullivan, ed., Protective Construction in a Nuclear Age, Vol. 1, Proceedings of the Second Protective Construction Symposium, 24-26 March, 1959 (New York: The MacMillan Company, 1961), pp. vi, 1-3. There is also a second volume, with the same editor and title.
2. S.M. Genensky and R.L. Loofbourow, Geological Covering Materials for Deep Underground Installations, U.S. Air Force Project Rand Research Memorandum RM-2617. Research sponsored by the U.S. Air Force under contract AF 49(638)-700, (Santa Monica, CA: The RAND Corp., 4 August 1960), p. 4.
3. Ibid, pp. 20-30.
4. Ibid, pp. 33-37.
5. Ibid, various pages throughout the document. There appears to be a minor geographical error in this report. It places the Vermilion Cliffs in Mohave County; however, the Vermilion Cliffs actually are in Coconino County, near the Kaibab National Forest.
6. David H. Morrissey, "Underground Depot to Replace Manzano Nuclear

Storage Site," Albuquerque Journal, 12 Sep 1989, pp. 1A and 3A.

7. Ibid; and John Fleck, "Bombs Away," Albuquerque Journal, 2 August 1992, pp. 1A and 6A.

8. Undated article, of uncertain origin, by Earl Zimmerman, entitled "LASL's Unusual Underground Lab," received from the Albuqerque Office of the Department of Energy, as an enclosure in a letter to the author.

9. EBE is an acronym used frequently in UFOlogy to refer to "Extraterrestrial Biological Entity". In plain English an EBE is an alien being, or an extraterrestrial being. The EBEs remored to be held at Los Alamos in the past were allegedly of the "Little Grey" type. I am unable to verify this allegation of EBEs being held at Los Alamos.

10. Harry V. Martin, various articles in an information packet obtained from the Napa Sentinel, ©1992. The Napa Sentinel is a weekly newspaper. Interested readers may contact the Sentinel at 925 Lincoln Ave., Napa, CA 94558 (707)257-6272.

11. U.S. Department of Defense, Department of the Army, Army Corps of Engineers, Design of Underground Installations in Rock: General Planning Considerations, Manual No. EM 1110-345-431 (1 January 1961), Page 7. The one manual in this series which I do not quote from is entitled Design of Underground Installations in Rock: Penetration and Explosion Effects, Manual No. EM-1110-345-434 (31 July 1961). It is also published by the U.S. Army Corps of Engineers.

12. _____, Heating and Air Conditioning of Underground Installations, Manual No. EM 1110-345-450 (30 Nov. 1959), pp. 5-7, and 83-85.

13. _____, Design of Underground Installations: Protective Features and Utilities, Manual No. EM 1110-345-435 (1 July 1961), pp. 5-6, 11-25, 62-74.

14. _____, Design of Underground Installations in Rock: Space Layouts and Excavation Methods, Manual No. EM 1110-345-433 (1 April 1961), pp. 5, 8 and 9-16.

15. U.S. Department of Defense, Department of the Army, U.S. Army Corps of Engineers, Army Engineer Waterways Experiment Station, Feasibility of Constructing Large Underground Cavities: Background, Site Selection, and Summary, Technical Report No. 3-648, Vol. I, July 1964, Sponsored by Advanced Research Projects Agency, ARPA Order No. 260-62, Amendment No. 1, pp. vii-viii, 26 and 31. (The U.S. Army Engineer Waterways Experiment Station in Vicksburg, Mississippi contracted out the study to the Colorado School of Mines Research Foundation, in Golden, Colorado and to Jacobs Associates Construction Engineers of San Francisco, California.)

16. Ibid, p. 31.

17. _____, Feasibility of Constructing Large Underground Cavities: Report On Cost and Constructability, Technical Report No. 3-648, Vol. III, June 1964, Sponsored by Advanced Research Projects Agency, ARPA Order No. 260-62, Amendment No. 1, p. 21.

18. _____, Feasibility of Constructing Large Underground Cavities: Background, Site Selection, and Summary, Vol. 1, pp. 35-66.

19. _____, Feasibility of Constructing Large Underground Cavities: Report on Cost and Constructability, Vol. III, various pages.

20. William M. Arkin and Richard W. Fieldhouse, Nuclear Battlefields: Global Links in the Arms Race, (Cambridge, Mass.: Ballinger Publishing Co., 1985), p. 211.

21. R. Hibbard, L. Pietrzak and S. Rubens, Subsurface Deployment of Naval Facilities. Report sponsored by Naval Facilities Engineering Command, contract no. N00025-72-C-0009, Federal Document No. AD-762 838, and the following number

of unknown significance CR-2-318, December 1972.
22. James Bamford, The Puzzle Palace: A Report on America's Most Secret
Agency (Houghton Mifflin Co., 1982; reprint ed., NY, NY: Penguin Books, 1983), p.
221.

Chapter Three -- The Ultimate War Rooms

1. Steven Emerson, "America's Doomsday Project," U.S. News & World Report, 7
Aug 1989, pp. 26-31.
2. Douglas Heuck, "'Underground Pentagon' Quietly Awaits Armageddon," The
Albuquerque Tribune, 25 November 1991, pp. 1D and 2D; Richard H.P. Sia, "As
Cold War Wanes, Pentagon's Pennsylvania Fortress Lifts Its Alert," The Baltimore
Sun, 20 April 1992, p. 1A and 10A; and William M. Arkin, Joshua M. Handler,
Julia A. Morrissey and Jacquelyn M. Walsh, Encyclopedia of the U.S. Military,
(New York: Harper and Row, Ballinger Division, 1990) p. 63.
3. Ted Gup, "The Doomsday Blueprints," Time (10 Aug 1992), p. 37.
4. John Guthrie, "Underground Command Posts," International Combat Arms, 5
(May 1987), p. 19.
5. Arkin and Fieldhouse, Nuclear Battlefields, p. 181; William R. Evinger, ed.,
Directory of Military Bases in the U.S., (Phoenix, AZ: Oryx Press, 1991), p. 33; and
Arkin et al, Encyclopedia of the U.S. Military, pp. 482-483.
6. John M. Norvell, "'The Rock'-NORAD COC," The Military Engineer, No. 367
(Sep-Oct 1963), pp. 309-311; and Guthrie, "Underground Command Posts," p. 19.
7. L.B. Leonberger, "Under the Pre-Cambrian Shield," Airman, 14 (March 1970),
pp. 11-12; K.G. Roberts, "Air Defence Goes Underground," The Roundel, 15 (Sep
1963), pp. 8-13; and "NORAD at North Bay: Underground Center a Joint Effort,"
Air Force Times, 29 (12 Feb 1969), p. 27.
8. Ted Gup, "Doomsday Hideaway," Time, 9 Dec 1991, pp. 26-29; and Richard
P. Pollock, "The Mysterious Mountain," The Progressive, March 1976, pp. 12-16.
9. Richard P. Pollock, "The Mysterious Mountain, The Progressive, March 1976,
pp. 12-16; and Ford Rowan, Technospies: The Secret Network That Spies on You --
and You (New York: G.P. Putnam's Sons, 1978), pp. 25-43.
10. Ibid; and Arkin, Handler, Morissey and Walsh, Encyclpedia of the U.S.
Military, pp. 177-179, 270-272.
11. U.S. Congress, Senate, Committee on the Judiciary and Committee on
Commerce, Surveillance Technology, Joint Hearings Before Subcommittees of the
Senate Committees on the Judiciary and Commerce. 94th Cong., 1st Session, 1975,
pp. 63-100.
12. Jack Anderson and Dale Van Atta, "Top Secret Hide-Outs Also Mask Flaws,"
The Washington Post, 29 August 1991, 23B.
13. Arkin and Fieldhouse, Nuclear Battlefields, p. 210.
14. Ted Gup, "The Ultimate Congressional Hideaway," The Washington Post
Magazine, 31 May 1992, p. 15; and Rowan, Technospies, pp. 34-35.
15. Rowan, Technospies, p. 35.
16. Ted Gup, "The Doomsday Blueprints," Time (10 August 1992), p. 38.
17. Arkin and Fieldhouse, Nuclear Battlefields, p. 193.
18. Ibid; and Arkin, Handler, Morissey and Walsh, Encyclopedia of the U.S.
Military, p. 273.
19. Robert D. Hershey, Jr., "A Bunker Just For Lawmakers Who Now May Run
For Cover," The New York Times, 31 May 1992, pp. 1 and 20; Tom Webb, "The
Last Resort," Albuquerque Journal, 30 May 1992, pp. 1A and 9A; and Ted Gup,

"The Ultimate Congressional Hideaway," The Washington Post Magazine, 31 May 1992, pp. 10-15, 24-27.
20. Arkin, Handler, Morrisey and Walsh, Encyclopedia of the U.S. Military, p. 273.
21. Letter to the author, dated 2 March 1993, from William F.W. Jones, Deputy Associate Director, National Preparedness Directorate, Federal Emergency Management Agency.
22. H.R. Pratt and S.J. Green, A Geology Compendium of the Continental United States - With Application to Deep-Based Systems, Report prepared by Terra Tek, Inc., Salt Lake City, Utah for the Defense Nuclear Agency. Federal Document No. DNA 3874F, 15 November 1975.
23. Oliver North, Under Fire: An American Story (New York: Harper Collins, 1991), pp. 164-166.
24. Tim Weiner, "Pentagon Book For Doomsday Is to Be Closed," New York Times, 18 April 1994.
25. "No Comment," The Progressive, 56 (August 1992), p. 11.

Chapter Four -- More Underground Facilities

1. "Logistics Goes Underground," Army Logistician, 6 (July-Aug 1974), pp. 32-33.
2. Ray Vicker, "Going Underground," The Wall Street Journal, 17 June 1981, p. 56.
3. Bamford, Puzzle Palace, p. 133.
4. The information on the plans for Yucca Mountain, Nevada comes from DIALOG FILE 194, an electronic database that catalogues announcements that appear in the Commerce Business Daily. Commerce Business Daily is a list of federal contract announcements and bid solicitations published every working day by the U.S. Department of Commerce. The announcements referenced here were published on 10 May 1991; 10 Feb 1992; 11 Sep 1992; and 22 Oct 1992. Responses were solicited by: Reynolds Electrical and Engineering Co. Inc., Yucca Mountain Project, PO Box 98521, Mail Stop 408, Las Vegas, NV 89193-8521.
5. Michael Martin Nieto, "Physics at the Proposed National Underground Science Facility," in Proceedings of the XIV International Symposium on Multiparticle Dynamics, Granlibakken, Lake Tahoe, California, 22-27 June 1983, ed. P. Yager and J.F. Gunion, scientific secretary K. Sparks (Singapore: World Scientific Publishing Co Pte Ltd., 1984), 1107-1119.
6. Ted Gup, "The Doomsday Blueprints," Time, 140 (10 August 1992), p. 38.
7. The material on the Northrop, McDonnell Douglas and Lockheed facilities, and associated strange goings-on, can be found in articles in the Nov 1992 issue of HUFON REPORT: The Newsletter of the Houston UFO Network, Inc., from PO Box 942, Bellaire, TX 77402 (713)850-1352.
8. Ray Vicker, "Going Underground," The Wall Street Journal, 17 June 1981, p. 56.
9. Per author's personal conversation with former AT&T emplyee.
10. Research Program Plan for Meeting Tomorrow's Needs in Tunneling and Excavation: Final Report, Federal Document Nos. NSF-RA-T-74-087 or PB 242 777, Contract C-841. Study performed by Bechtel Corporation for the National Science Foundation, Research Applied to National Needs (RANN), March 1974, p. 53.
11. "Demand Forecast of Underground Construction and Mining in the United States," Subcommittee on Demand Forecasting, U.S. National Committee on

Tunneling Technology, Assembly of Engineering, National Research Council, Federal Document number NRC/AE/TT-81-1 (Washington, D.C.: National Academy Press, 1981), p. 20.

Chapter Five -- The Mother of All Underground Tunnels?

1. U.S. National Committee on Tunneling Technology, U.S. National Committee on Tunneling Technology Report for 1977, NTIS, PB-300 527; also might be found under Federal Technical Document No. NSF/RA-780668. As of 1983 the address of the committee was: U.S. National Committee on Tunneling Technology, National Research Council, 2101 Constitution Avenue, NW, Washington, DC 20418.

2. U.S. National Committee on Tunneling Technology, Report for 1981 and 1982, U.S. National Committee on Tunneling Technology (Washington, D.C.: National Academy Press, 1983).

3. W.G. Harris and H. Oman, "Chlorine as an Oxidizer for Fuel Cells and Its Containment," Boeing Aerospace Company report, in 19th Intersociety Energy Conversion Engineering Conference, Vol. 2, "Advanced Energy Systems -- Their Role In Our Future," (San Francisco, CA: American Nuclear Society, 19-24 August 1984), pp. 810-814.

4. Design and Construction of Deep Underground Basing Facilities for Strategic Missiles, Vol. 1, Evaluation of Technical Issues. Report of a Workshop Conducted by the U.S. National Committee on Tunneling Technology, Commission on Engineering and Technical Systems, National Research Council, federal technical document no. NRC/CETS/TT-82-1 (Washington, D.C.: National Academy Press, 1982). This report is 68 pages long and worth reading in its entirety. I have only culled out some highlights.

5. George B. Clark, Levent Ozdemir and Fun-Den Wang, Tunnel Boring Machine Technology for a Deeply Based Missile System, Volume II, State-of-the-Art Review, report prepared by Colorado School of Mines, Golden, Colorado 80401, for the Air Force Weapons Laboratory at Kirtland Air Force Base, New Mexico 87117, Federal Technical Document No. AFWL-TR-79-120, Vol. II, August 1980. Also, George B. Clark, Levent Ozdemir and Fun-Den Wang, Tunnel Boring Machine Technology for a Deeply Based Missile System, Volume I, Part 1, Application Feasibility. Report prepared by Colorado School of Mines, Golden, Colorado, for the Air Force Weapons Laboratory at Kirtland Air Force Base, New Mexico 87117, Federal Technical Document No. AFWL-TR-79-120, Vol. 1, Part 1, August 1980.

6. Richard Halloran, "Air Force Seeks Missile Base Deep Underground for 1990s," The New York Times, 3 Oct 1984, pp. A1 and A23.

7. "A Subterranean Air Force?" Asian Defence Journal, April 1985, p. 97.

8. John J. Cipar, Explosion-Induced Ground Motion Within a Deep Base. Report prepared for Air Force Geophysics Laboratory, Hanscom Air Force Base, Massachusetts 01731, Federal Technical Document No. AFGL-TR-85-0339. Environmental Research Papers No. 940, 8 Nov 1985.

9. "ICBM Deep Basing Construction Planning Study," paper presented by Patrick D. Lindsey of the U.S. Army Corps of Engineers, Omaha District, Nebraska, in 26th U.S. Symposium on Rock Mechanics/Rapid City, SD, 26-28 June 1985, pp. 1189-1196.

10. U.S. National Committee on Tunneling Technology and U.S. National Committee for Rock Mechanics, "Advances in Technology for the Construction of Deep-Underground Facilities," Tunnelling and Underground Space Technology 3 (1988), pp. 25-44.

11. Department of Defense News Release, 7 November 1985, vol. 85, no. 652, p. 2. This reference was accessed through DIALOG FILE 80. DIALOG is a computer data base.
12. Department of Defense News Release, 6 December 1985, vol. 85, no. 700, p. 1. Reference accessed through DIALOG FILE 80.
13. Department of Defense News Release, 24 April 1986, vol. 86, no. 180, p. 2. Reference accessed through DIALOG FILE 80.
14. Department of Defense News Release, 19 August 1987, vol. 87, no. 416, p. 3. Reference accessed through DIALOG FILE 80.
15. Department of Defense News Release, 29 July 1985, vol. 85, no. 450, p. 2. Reference accessed through DIALOG FILE 80.
16. Though this makes little sense, since both the French and the Japanese have high speed, inter-city rail systems, and in both cases the systems are almost completely on the surface. In neither case have the designers created an extensive, underground tunnel network as set forth in the United States Department of Transportation (DOT) plans. Could the DOT plans really be for a secret tunnel system, published under the guise of an inter-city, mass transit project that actually never was intended for public use?
17. High Speed Ground Transportation Tunnel Design and Cost Data, Report prepared by HARZA Engineering Company, Chicago under subcontract WO356-SC, under prime contract C-353-66 (NEG), for the Office of High Speed Ground Transportation, United States Department of Transportation, Federal Document No. PB 178-201, (also carries following number of unknown significance on the title page: 06818-W454-R0-11), document dated March 1968.

Chapter Six -- Tunnelling Machines

1. J. George Thon, "Tunnel-Boring Machines," in Tunnel Engineering Handbook, ed. John O. Bickel and T.R. Kuesel (New York: Van Nostrand Reinhold Co., 1982), pp. 235-278.
2. Ibid, pp. 244-247.
3. Underground Structures, Design and Construction, ed. R.S. Sinha (New York: Elsevier Science Publishing Co., Inc., 1991), 293-299.
4. Research Program Plan for Meeting Tomorrow's Needs in Tunneling and Excavation -- Final Report. Report prepared by Bechtel Corporation for the National Science Foundation, Research Applied to National Needs (RANN), federal technical document no. NSF-RA-T-74-087, or Federal No. PB 242 777, March 1974, p. 224.
5. "Research and Development," Government Executive 3 (Jan 1971), pp. 22-23.
6. J. George Thon, "Tunnel-Boring Machines," in Tunnel Engineering Handbook, pp. 275-276.
7. Feasibility of Flame-Jet Tunneling, Vol. I -- Summary Report. Report by United Aircraft Research Laboratories, United Aircraft Corporation, East Hartford, Connecticut, for U.S. Department of Transportation, Office of High Speed Ground Transportation, Federal Document No. G-910560-10, or PB-178198, May 1968.
8. Feasibility of Flame-Jet Tunneling, Vol. II -- Systems Analysis and Experimental Investigations, Report by United Aircraft Research Laboratories and Browning Engineering Corp., for U.S. Dept. of Transportation, Office of High Speed Ground Transportation, Federal Document No. G-910560-10, or PB-178199, May 1968.
9. R.T. Avery, D. Keefe, T.L. Brekke and I. Finnie, "Hard Rock Tunneling Using

Footnotes

Pulsed Electron Beams," in Accelerator Division Annual Reports, 1 July 1972 -- 31 December 1974, LBL-3835, UC-28 Particle Accelerators, TID-4500-R62, Lawrence Berkeley Laboratory, University of California, Berkeley, CA, pp. 29-32.

10. U.S. Patent No. 3,693,731, 26 Sep 1972.

11. U.S. Patent No. 3,881,777, 6 May 1975.

12. U.S. Patent No. 3,885,832, 27 May 1975.

13. J.H. Altseimer, Systems and Cost Analysis for a Nuclear Subterrene Tunneling Machine: A Preliminary Study, Federal Technical Document No. LA-5354-MS, Informal Report UC-38, Sep 1973, p. 1.

14. John D. Bledsoe, J. Ernest Hill and Richard F. Coon, Cost Comparison Between Subterrene and Current Tunneling Methods, Appendix A, Baseline Cost Analyses, prepared for National Science Foundation, by A.A. Mathews, Inc., Rockville, MD, Federal Document No. NSF-RA-T-75-001A, also No. PB 244 482, May 1975. Also John D. Bledsoe, J. Ernest Hill and Richard F. Coon, Cost Comparison Between Subterrene and Current Tunneling Methods, Appendix B, Subterrene Cost Analyses, prepared for National Science Foundation, by A.A. Mathews, Inc., Rockville, MD, Federal Document No. NSF-RA-T-75-001B, PB 244 483, May 1975; and John D. Bledsoe, J. Ernest Hill and Richard F. Coon, Cost Comparison Between Subterrene and Current Tunneling Methods, Final Report, prepared for National Science Foundation, by A.A. Mathews, Inc., Rockville, MD, Federal Document No. NSF-RA-T-75-001, May 1975.

15. Joseph W. Neudecker, Jr., James D. Blacic and John C. Rowley, Subselene: A Nuclear Powered Melt Tunneling Concept for High-Speed Lunar Subsurface Transportation Tunnels, submitted to Symposium '86, Atlantic City, NJ, 22-24 Sep 1986, prepared by Los Alamos National Laboratory, Los Alamos, NM 87545, Federal Document No. LA-UR-86-2897, December 1986.

16. Christopher S. Allen, David W. Cooper, David Davila Jr., Christopher S. Mahendra and Michael A. Tagaras, Proposal for a Lunar Tunnel-Boring Machine, report presented to Prof. Stan Lowy, Dept. of Aerospace Engineering, Texas A&M Univ., research funded by NASA/USRA Grant, 5 May 1988, pp. ii and 15.

17. Ibid, p. 49.

18. Bill Engblom, Eric Graham, Jeevan Perera, Alan Strahan and Ted Ro, Subselenean Tunneler Melting Head Design: A Preliminary Study, by Texas A&M Aerospace Engineering, College Station, TX 77840, Federal Technical Document No. N89-17058, or NASA-CR-184750, May 1988.

Chapter Seven -- Nuclear Testing, The EPA, Abductions

1. All information and illustrations cited or used in this article that pertain to the government program that monitors humans and animals are from the following document: U.S. Congress, Office of Technology Assessment, The Containment of Underground Nuclear Explosions, OTA-ISC-414 (Washington, DC: U.S. Government Printing Office, October, 1989), pp. 65-80.

Chapter Eight -- Abductions, Needles and Implants

1. Texas Instruments, Inc. and the huge General Motors subsidiary, Hughes Aircraft Co., are two of the companies involved in this field. There are a number of others. "Texas Instruments Enters Automatic Identification Market," Feedstuffs 63 (1 April 1991), p. 18; and "TI Sets Volume Transponder Production for IDs," Electronic News 38 (21 September 1992), p. 16.

2. A General Motors subsidiary, Hughes Aircraft Co., is co-assignee for one of the patents (United States Patent 5,211,129, dated 18 May 1993). Hughes Aircraft subsequently formed its own electronic identification company, known as Hughes ID. "Hughes Enters ID Market," Microwaves & RF 31 (January 1992), p. 21.

3. United States Patent 5,211,129, granted 18 May 1993.

4. United States Patent 5,250,026 granted 5 October 1993.

5. United States Patents: 4,730,188 granted 8 March 1988; 5,041,826 granted 20 August 1991; and 5,166,676 granted 24 November 1992.

6. United States Patent 5,041,826, granted 20 August 1991.

7. I do not claim to know the ultimate reason(s) for the abductions. Given the bizarre nature of the phenomenon, though, I am prepared to believe that the underlying motivations may appear, in the ordinary perceptual framework of humanity, to be highly strange.

8. The fact that young children and older people who may be infertile are also abducted need not invalidate this hypothesis. Children with desirable traits may be targeted early on, perhaps because of a genetic heritage that is of interest to the abductors. And whether young or old, it may be that other bodily tissues, all of which contain the genetic material (DNA) of the abductee, can be used in place of sperm or ova.

9. I have no proof that there are functional, artificial wombs for human fetuses. For the sake of the hypothesis I am postulating that they may exist. But even if they don't, contemporary medical technology still admits both of artificial insemination using donor sperm and in vitro fertilization.

10. I am reminded of Charles Fort, who questioned whether this planet and the human race might not be someone's "property."

11. The metaphor of the hall of mirrors, and the idea that very human terrestrials (including the military), operating behind an intricate, technologically sophisticated web of deception and disinformation, may well be at work in the UFO/abduction phenomenon are mentioned in Jacques Vallée's excellent book Revelations: Alien Contact and Human Deception (New York: Ballantine Books, 1991). Martin Cannon, of Prevailing Winds Research has also advanced the idea of covert, human involvement in the abduction and implantation phenomena. More recently, Leah Haley has written of her experiences with joint military and "alien" abductions. Finally, I would ask readers to please note that my objective with the whole abduction/implant phenomenon is simply to present relevant facts, present a possible hypothesis that may shed some light on the subject, and thereby to stimulate a more informed discussion.

Chapter Nine -- Is the U.S. Military Involved in "Alien" Cattle Mutilations?

1. "Laser Medical Pac," Fact Sheet, Office of Public Affairs, Phillips Laboratory (505)-846-1911, 3550 Aberdeen Ave SE, Kirtland AFB, NM 87117-5776, January 1994.

INDEX
Illustration numbers are boldfaced

NEW BOOKS FROM ADVENTURES UNLIMITED

ANCIENT MICRONESIA
& the Lost City of Nan Madol
by David Hatcher Childress

Micronesia, a vast archipelago of islands west of Hawaii and south of Japan, contains some of the most amazing megalithic ruins in the world. Part of our *Lost Cities of the Pacific* series, this volume explores the incredible conformations on various Micronesian islands, especially the fantastic and little-known ruins of Nan Madol on Pohnpei Island. The huge canal city of Nan Madol contains over 250 million tons of basalt columns over an 11 square-mile area of artificial islands. Much of the huge city is submerged, and underwater structures can be found to an estimated 80 feet. Islanders' legends claim that the basalt rocks, weighing up to 50 tons, were magically levitated into place by the powerful forefathers. Other ruins in Micronesia that are profiled include the Latte Stones of the Marianas, the menhirs of Palau, the megalithic canal city on Kosrae Island, megaliths on Guam, and more.
256 PAGES. 6x9 PAPERBACK. HEAVILY ILLUSTRATED. INCLUDES A COLOR PHOTO SECTION. BIBLIOGRAPHY & INDEX. $16.95. CODE: AMIC

FAR-OUT ADVENTURES
The Best of World Explorer Magazine

This is a thick compilation of the first nine issues of *WORLD EXPLORER* in a large-format paperback. Included are all the articles, cartoons, satire and such features as the Crypto-Corner, the News Round-Up, Letters to the Editor, the Odd-Ball Gallery and the many far-out advertisements. World Explorer has been published periodically by THE WORLD EXPLORERS CLUB for almost eight years now. It is on sale at Barnes & Noble Bookstores and has become a cult magazine among New Agers and Fortean Researchers. Authors include David Hatcher Childress, Joseph Jochmans, John Major Jenkins. Deanna Emerson, Katherine Routledge, Alexander Horvat, John Tierney, Greg Deyermenjian, Dr. Marc Miller, and others. Articles in this book include Smithsonian Gate, Dinosaur Hunting In the Congo, Secret Writings of the Incas, On the Track of the Yeti, Secrets of the Sphinx, Living Pterodactyls, Quest For Atlantis, What Happened To the Great Library of Alexandria?, In Search of Seamonsters, Egyptians In the Pacific, Lost Megaliths of Guatemala, The Mystery of Easter Island. Comacalco: Mayan City of Mystery, and plenty more.
520 PAGES, 8x11 PAPERBACK. ILLUSTRATED. $19.95. CODE: FOA

SECRET CITIES OF OLD SOUTH AMERICA
Atlantis Reprint Series
by Harold T. Wilkins

The reprint of Wilkin's classic book, first published in 1952, claiming that South America was Atlantis. Chapters include Mysteries of a Lost World; Atlantis Unveiled; Red Riddles on the Rocks; South America's Amazons Existed!; The Mystery of El Dorado and Gran Payatiti—the Final Refuge of the Incas; Monstrous Beasts of the Unexplored Swamps & Wilds; Weird Denizens of Antediluvian Forests; New Light on Atlantis from the World's Oldest Book; The Mystery of Old Man Noah and the Arks; and more.
438 PAGES. 6x9 PAPERBACK. HEAVILY ILLUSTRATED. BIBLIOGRAPHY & INDEX. $16.95. CODE: SCOS

ATLANTIS IN AMERICA
Navigators of the Ancient World
by Ivar Zapp and George Erikson

This book is an intensive examination of the archeological sites of the Americas, an examination that reveals civilization has existed here for tens of thousands of years. Zapp is an expert on the enigmatic giant stone spheres of Costa Rica, and maintains that they were sighting stones found throughout the Pacific as well as in Egypt and the Middle East. They were used to teach star-paths and sea to the world-wide navigators of the ancient world. While the Mediterranean and European regions "forgot" world-wide navigation and fought wars the Mesoamericans of diverse races were building vast interconnected cities without walls. This Golden Age of ancient America was merely a myth of suppressed history—until now. Profusely illustrated, chapters are on Navigators of the Ancient World; Pyramids & Megaliths: Older Than You Think; Ancient Ports and Colonies; Cataclysms of the Past; Atlantis: From Myth To Reality; The Serpent and the Cross: The Loss of the City States; Calendars and Star Temples; and more.
360 PAGES. 6x9 PAPERBACK. ILLUSTRATED. BIBLIOGRAPHY & INDEX. $17.95. CODE: AIA

MAPS OF THE ANCIENT SEA KINGS
Evidence of Advanced Civilization in the Ice Age
by Charles H. Hapgood

Charles Hapgood's classic 1966 book on ancient maps produces concrete evidence of an advanced world-wide civilization existing many thousands of years before ancient Egypt. He has found the evidence in the Piri Reis Map that shows Antarctica, the Hadji Ahmed map, the Oronteus Finaeus and other amazing maps. Hapgood concluded that these maps were made from more ancient maps from the various ancient archives around the world, now lost. Not only were these unknown people more advanced in mapmaking than any people prior to the 18th century, it appears they mapped all the continents. The Americas were mapped thousands of years before Columbus. Antarctica was mapped when its coasts were free of ice.
316 PAGES. 7x10 PAPERBACK. ILLUSTRATED. BIBLIOGRAPHY & INDEX. $19.95. CODE: MASK

24 HOUR CREDIT CARD ORDERS—CALL: 815-253-6390 FAX: 815-253-6300
email: auphq@frontiernet.net http://www.azstarnet.com/~aup

ANTI-GRAVITY

THE FREE-ENERGY DEVICE HANDBOOK
A Compilation of Patents and Reports
by David Hatcher Childress

A large-format compilation of various patents, papers, descriptions and diagrams concerning free-energy devices and systems. *The Free-Energy Device Handbook* is a visual tool for experimenters and researchers into magnetic motors and other "over-unity" devices. With chapters on the Adams Motor, the Hans Coler Generator, cold fusion, superconductors, "N" machines, space-energy generators, Nikola Tesla, T. Townsend Brown, and the latest in free-energy devices. Packed with photos, technical diagrams, patents and fascinating information, this book belongs on every science shelf. With energy and profit being a major political reason for fighting various wars, free-energy devices, if ever allowed to be mass-distributed to consumers, could change the world! Get your copy now before the Department of Energy bans this book!
292 PAGES. 8X10 TRADEPAPER. ILLUSTRATED. BIBLIOGRAPHY. $16.95. CODE: FEH

THE BRIDGE TO INFINITY
Harmonic 371244
by Captain Bruce Cathie

Cathie has popularized the concept that the earth is criss-crossed by an electromagnetic grid system that can be used for anti-gravity, free energy, levitation and more. The book includes a new analysis of the harmonic nature of reality, acoustic levitation, pyramid power, harmonic receiver towers and UFO propulsion. It concludes that today's scientists have at their command a fantastic store of knowledge with which to advance the welfare of the human race.
204 PAGES. 6X9 TRADEPAPER. ILLUSTRATED. $14.95. CODE: BTF

THE ENERGY GRID
Harmonic 695, The Pulse of the Universe
by Captain Bruce Cathie

This is the breakthrough book that explores the incredible potential of the Energy Grid and the Earth's Unified Field all around us. Bruce Cathie's first book *Harmonic 33*, was published in 1968 when he was a commercial pilot in New Zealand. Since then Captain Bruce Cathie has been the premier investigator into the amazing potential of the infinite energy that surrounds our planet every microsecond. Cathie investigates the Harmonics of Light and how the Energy Grid is created. In this amazing book are chapters on UFO propulsion, Nikola Tesla, Unified Equations, the Mysterious Aerials, Pythagoras & the Grid, Nuclear detonation and the Grid, maps of the ancients, an Australian Stonehenge examined, more.
255 PAGES. 6X9 TRADEPAPER. ILLUSTRATED. $15.95. CODE: TEG

UFOS AND ANTI-GRAVITY
Piece For A Jig-Saw
by Leonard G. Cramp

Leonard G. Cramp's 1966 classic book on flying saucer propulsion and suppressed technology is available again. *UFOS & Anti-Gravity: Piece For A Jig-Saw* is a highly technical look at the UFO phenomena by a trained scientist. Cramp first introduces the idea of 'anti-gravity' and introduces us to the various theories of gravitation. He then examines the technology necessary to build a flying saucer and examines in great detail the technical aspects of such a craft. Cramp's book is a wealth of material and diagrams on flying saucers, anti-gravity, suppressed technology, G-fields and UFOs. Chapters include Crossroads of Aerodynamics, Aerodynamic Saucers, Limitations of Rocketry, Gravitation and the Ether, Gravitational Spaceships, G. Field Lift Effects, The Bi-Field Theory, VTOL and Hovercraft, Analysis of UFO photos, more. "I feel the Air Force has not been giving out all available information on these unidentified flying objects. You cannot disregard so many unimpeachable sources." — John McCormack, Speaker of the U.S. House of Representatives.
388 PAGES. 6X9 PAPERBACK. HEAVILY ILLUSTRATED. $16.95. CODE: UAG

MAN-MADE UFOS 1944—1994
Fifty Years of Suppression
by Renato Vesco & David Hatcher Childress

A comprehensive look at the early "flying saucer technology" of Nazi Germany and the genesis of early man-made UFOs. This book takes us from the work of captured German scientists, to escaped battalions of Germans, secret communities in South America and Antarctica to todays state-of-the-art "Dreamland" flying machines. Heavily illustrated, this astonishing book blows the lid off the "government UFO conspiracy" and explains with technical diagrams the technology involved. Examined in detail are secret underground airfields and factories; German secret weapons; "suction" aircraft; the origin of NASA; gyroscopic stabilizers and engines; the secret Marconi aircraft factory in South America; and more. Not to be missed by students of technology suppression, secret societies, anti-gravity, free energy conspiracy and World War II! Introduction by W.A. Harbinson, author of the Dell novels *GENESIS* and *REVELATION*.
318 PAGES. 6X9 TRADEPAPER. ILLUSTRATED. INDEX & FOOTNOTES. $18.95. CODE: MMU

24 HOUR CREDIT CARD ORDERS—CALL: 815-253-6390 FAX: 815-253-6300
email: auphq@frontiernet.net http://www.azstarnet.com/~aup

MYSTIC TRAVELLER SERIES

MYSTERY CITIES OF THE MAYA

MYSTERY CITIES OF THE MAYA
Exploration and Adventure in Lubaantun & Belize
by Thomas Gann

First published in 1925, Mystery Cities of the Maya is a classic in Central American archaeology-adventure. Gann was close friends with Mike Mitchell-Hedges, the British adventurer who discovered the famous crystal skull with his adopted daughter Sammy and Lady Richmond Brown, their benefactress. Gann battles pirates along Belize's coast and goes upriver with Mitchell-Hedges to the lost city of Lubaantun where they excavate a strange lost city where the crystal skull was discovered. Lubaantun is a unique city in the Mayan world as it is built out of precisely carved blocks of stone without the usual plaster-cement facing. Lubaantun contained several large pyramids partially destroyed by earthquakes and a large amount of artifacts. Gann was a keen archaeologist, a member of the Mayan society, and shared Michell-Hedges belief in Atlantis and lost civilizations, pre-Mayan, in Central America and the Caribbean. Lots of good photos, maps and diagrams from the 20s.
252 PAGES. 6x9 PAPERBACK. ILLUSTRATED. $16.95. CODE: MCOM

THE MYSTERY OF EASTER ISLAND

THE MYSTERY OF EASTER ISLAND
by Katherine Routledge

The reprint of Katherine Routledge's classic archaeology book on Easter Island which was first published in London in 1919. Portions of the book later appeared in *National Geographic* (1924). Heavily illustrated with a wealth of old photos, this book is a treasure of information on that most mysterious of islands: Rapa Nui or Easter Island. The book details Katherine Routledge's journey by yacht from England to South America, around Patagonia to Chile and on to Easter Island. Routledge explored the amazing island and produced one of the first-ever accounts of the life, history and legends of this strange and remote place. Routledge discusses the statues, pyramid-platforms, Rongo Rongo script, the Bird Cult, the war between the Short Ears and the Long Ears, exploring the secret caves, ancient roads on the island, and more. This rare book on Easter Island serves as a sourcebook on the early discoveries and theories on the island. Original copies, when found, sell for hundreds of dollars so get this valuable reprint now at an affordable price.
432 PAGES. 6x9 PAPERBACK. ILLUSTRATED. $16.95. CODE: MEI

IN SECRET TIBET
T. Illion

IN SECRET TIBET
by Theodore Illion.

Reprint of a rare 30's travel book. Illion was a German traveller who not only spoke fluent Tibetan, but travelled in disguise through forbidden Tibet when it was off-limits to all outsiders. His incredible adventures make this one of the most exciting travel books ever published. Includes illustrations of Tibetan monks levitating stones by acoustics.
210 PAGES. 6x9 PAPERBACK. ILLUSTRATED. $15.95. CODE: IST

DARKNESS OVER TIBET
by Theodore Illion.

In this second reprint of the rare 30's travel books by Illion, the German traveller continues his travels through Tibet and is given the directions to a strange underground city. As the original publisher's remarks said, this is a rare account of an underground city in Tibet by the only Westerner ever to enter it and escape alive!
210 PAGES. 6x9 PAPERBACK. ILLUSTRATED. $15.95. CODE: DOT

IN SECRET MONGOLIA

IN SECRET MONGOLIA
Sequel to Men & Gods In Mongolia
by Henning Haslund

Danish-Swedish explorer Haslund's first book on his exciting explorations in Mongolia and Central Asia. Haslund takes us via camel caravan to the medieval world of Mongolia, a country still barely known today. First published by Kegan Paul of London in 1934, this rare travel adventure back in print after 50 years. Haslund and his camel caravan journey across the Gobi Desert. He meets with renegade generals and warlords, god-kings and shamans. Haslund is captured, held for ransom, thrown into prison, battles black magic and portrays in vivid detail the birth of new nation. Haslund's second book *Men & Gods In Mongolia* is also available from Adventures Unlimited Press.
374 PAGES. 6x9 PAPERBACK. ILLUSTRATED WITH MAPS, PHOTOS AND DIAGRAMS. BIBLIOGRAPHY & INDEX. $16.95. CODE: ISM

MYSTIC TRAVELLER SERIES

MEN & GODS IN MONGOLIA
by Henning Haslund

First published in 1935 by Kegan Paul of London, Haslund takes us to the lost city of Karakota in the Gobi desert. We meet the Bodgo Gegen, a God-king in Mongolia similar to the Dalai Lama of Tibet. We meet Dambin Jansang, the dreaded warlord of the "Black Gobi." There is even material in this incredible book on the Hi-mori, an "airhorse" that flies through the air (similar to a Vimana) and carries with it the sacred stone of Chintamani. Aside from the esoteric and mystical material, there is plenty of just plain adventure: caravans across the Gobi desert, kidnapped and held for ransom, initiation into Shamanic societies, warlords, and the violent birth of a new nation.
358 PAGES. 6x9 PAPERBACK. 57 PHOTOS, ILLUSTRATIONS AND MAPS. $15.95. CODE: MGM

24 HOUR CREDIT CARD ORDERS—CALL: 815-253-6390 FAX: 815-253-6300

HTTP://WWW.AZSTARNET.COM/~AUP